W9-BZX-277

posh®

Coloring
BOOK

· · · · · · · · · · · ·

HAPPY DOODLES
FOR FUN & RELAXATION

Flora Chang

· · · · · · · · · · · ·

Andrews McMeel
Publishing®

a division of Andrews McMeel Universal

POSH® COLORING BOOK
HAPPY DOODLES FOR FUN & RELAXATION

copyright © 2016 by Flora Chang. All rights reserved.
Printed in the United States of America. No part of this book may
be used or reproduced in any manner whatsoever without written
permission except in the case of reprints in the context of reviews.

Andrews McMeel Publishing
a division of Andrews McMeel Universal
1130 Walnut Street, Kansas City, Missouri 64106

www.andrewsmcmeel.com

16 17 18 19 20 MLY 10 9 8 7

ISBN: 978-1-4494-7558-1

ATTENTION: SCHOOLS AND BUSINESSES
Andrews McMeel books are available at quantity discounts
with bulk purchase for educational, business, or sales
promotional use. For information, please e-mail the
Andrews McMeel Publishing Special Sales Department:
specialsales@amuniversal.com.

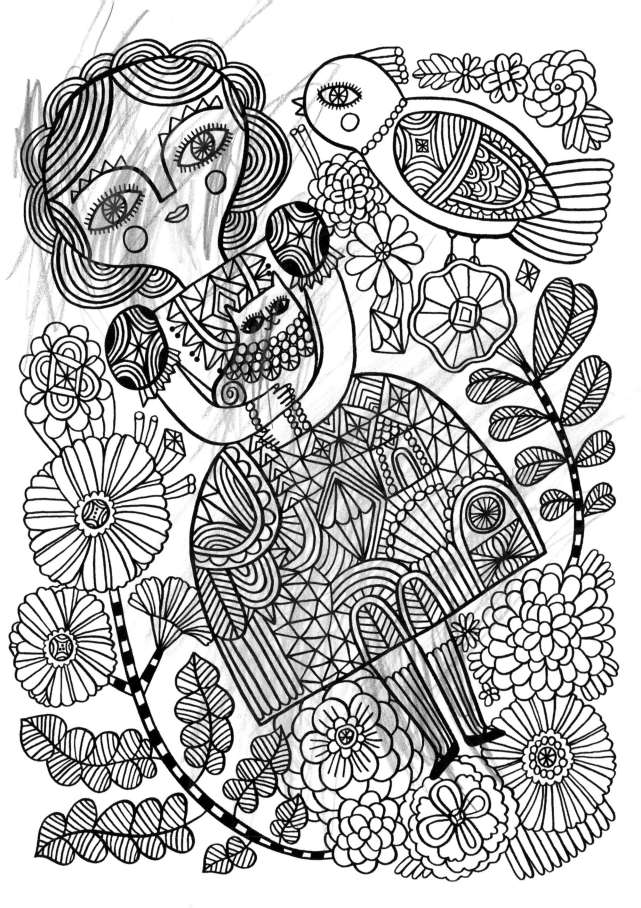

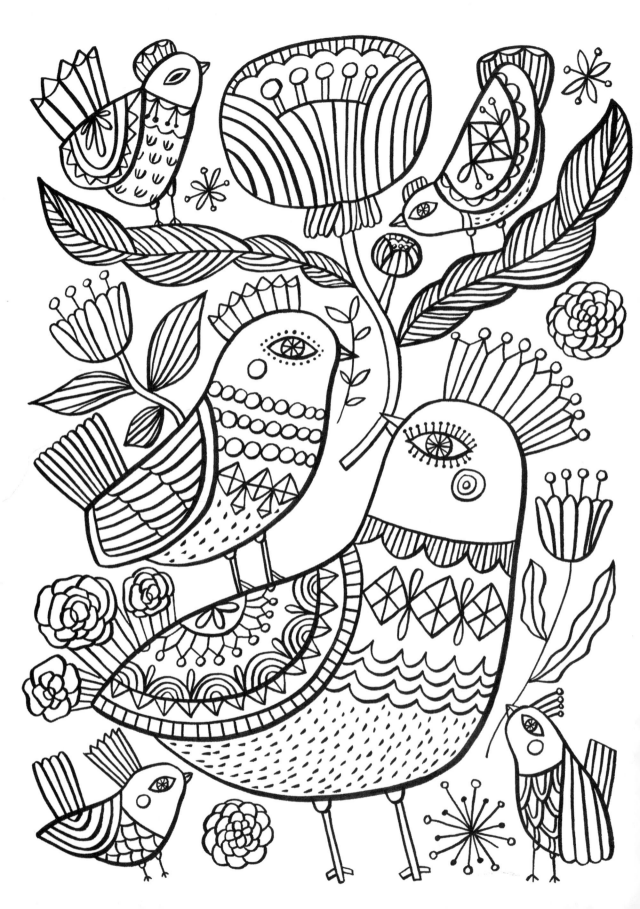

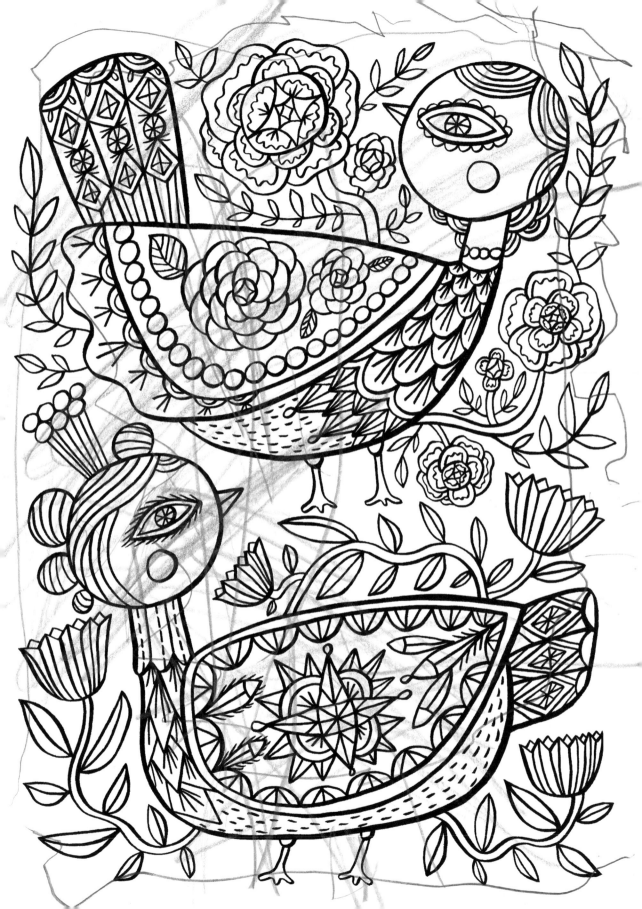

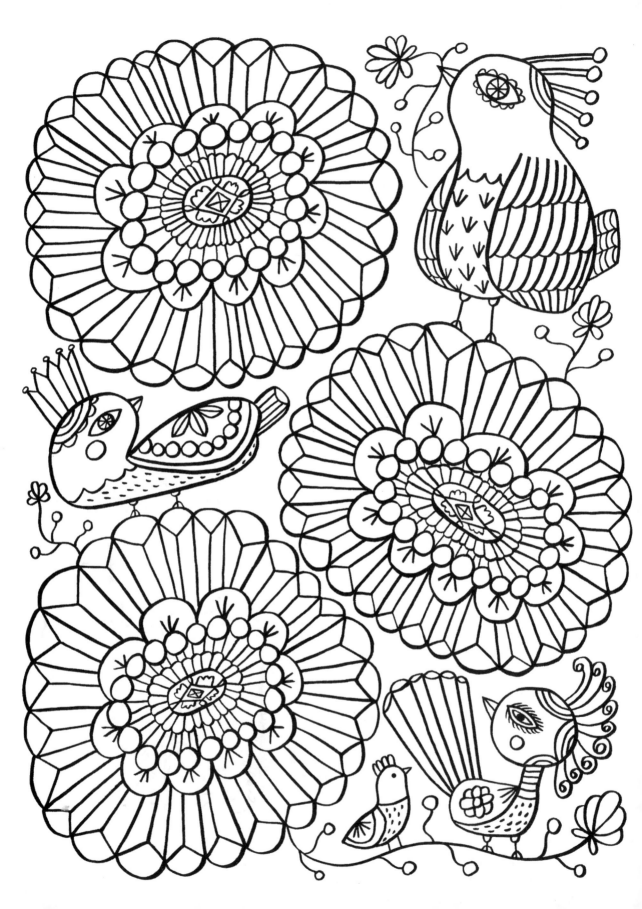

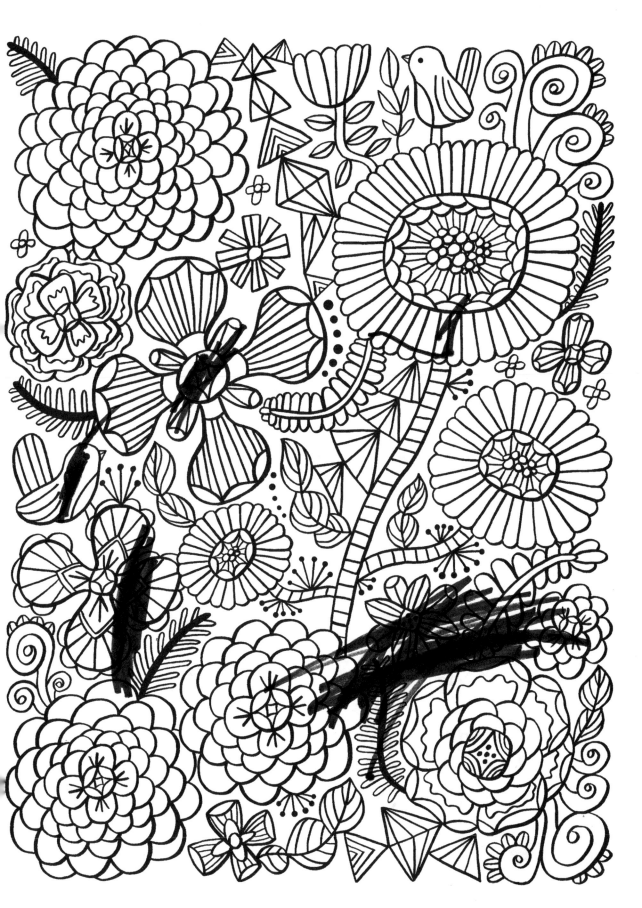

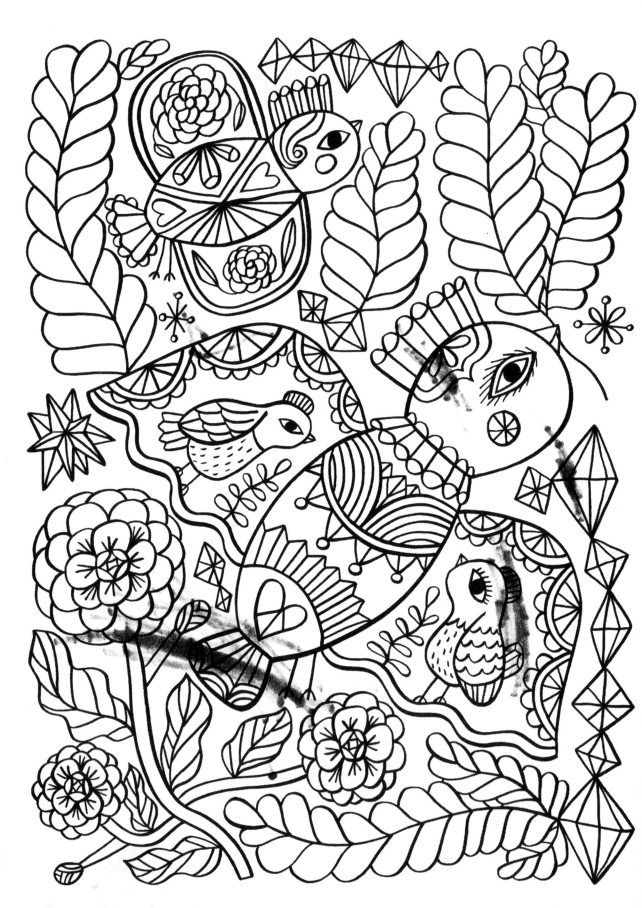

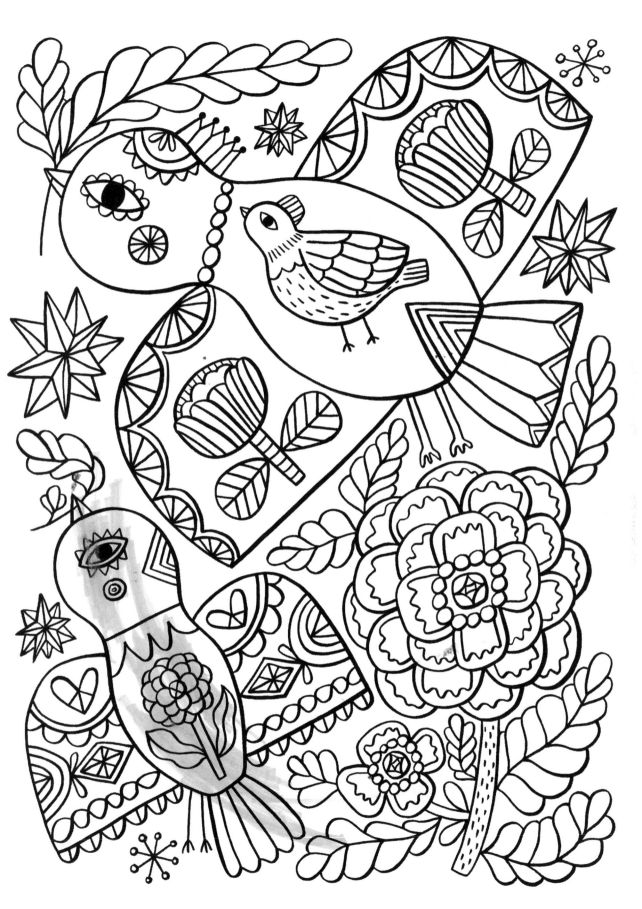

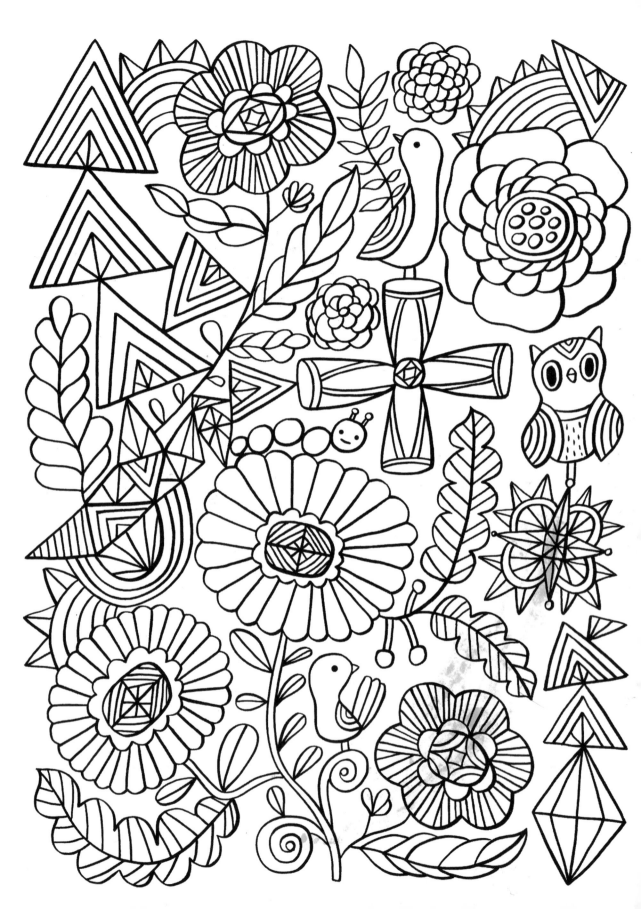

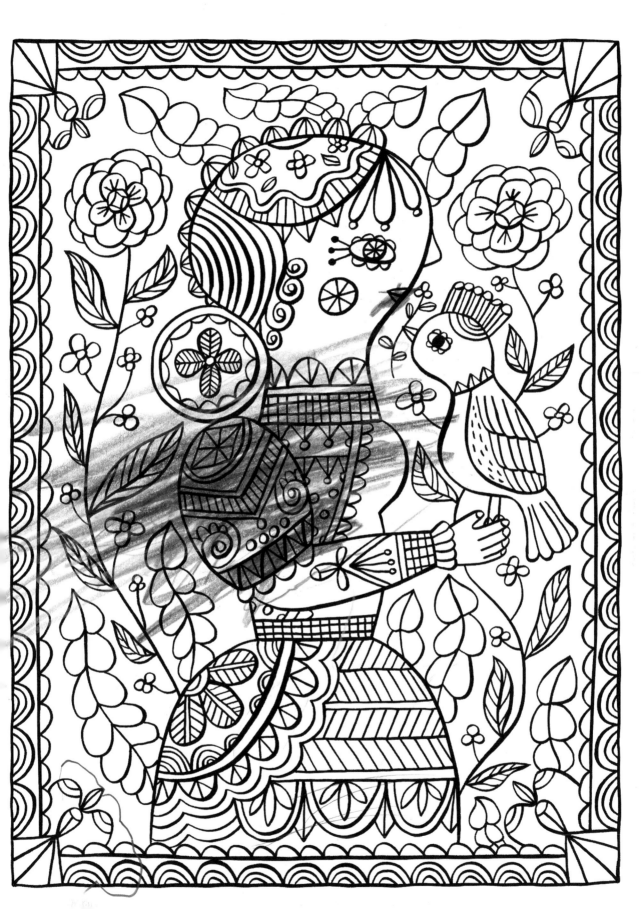

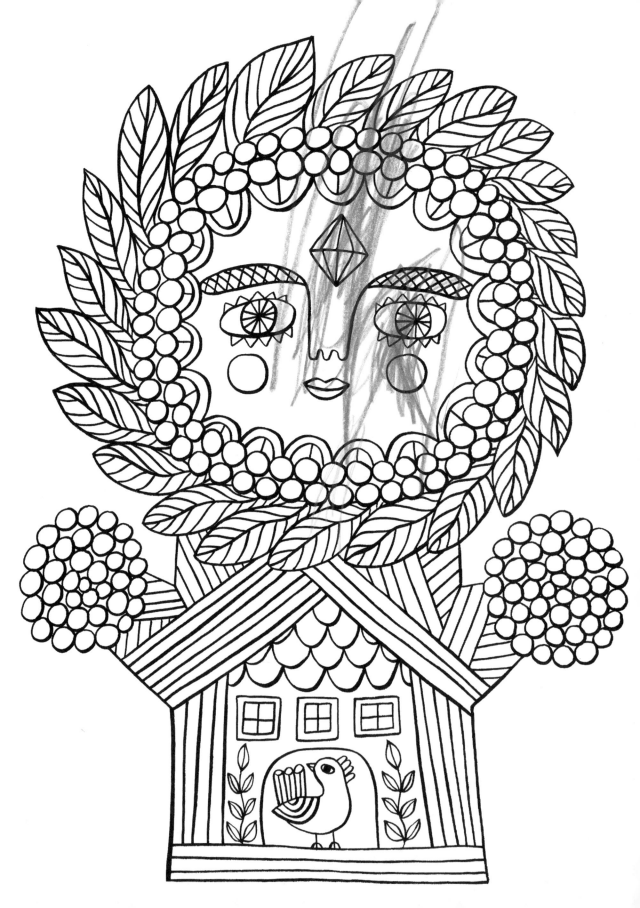

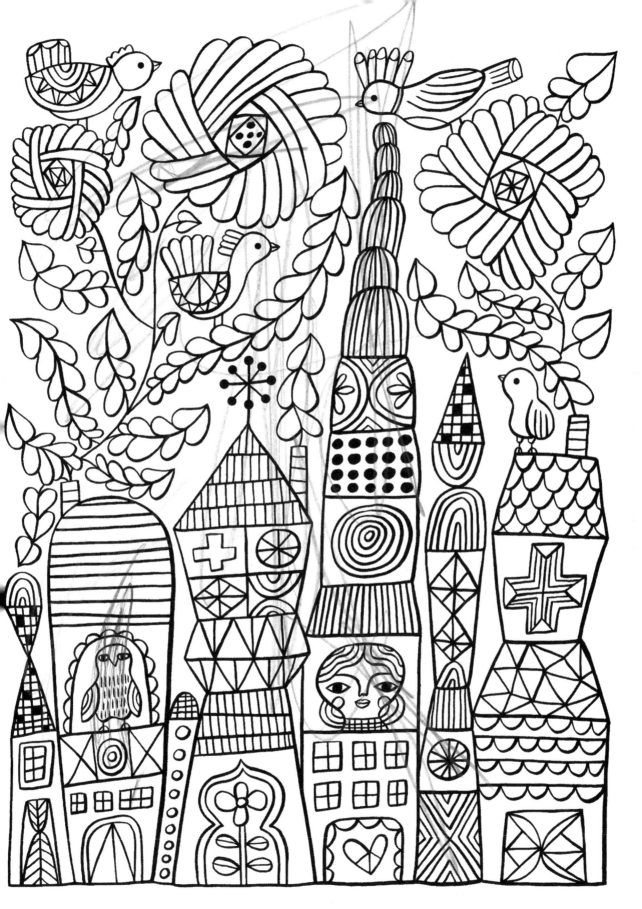

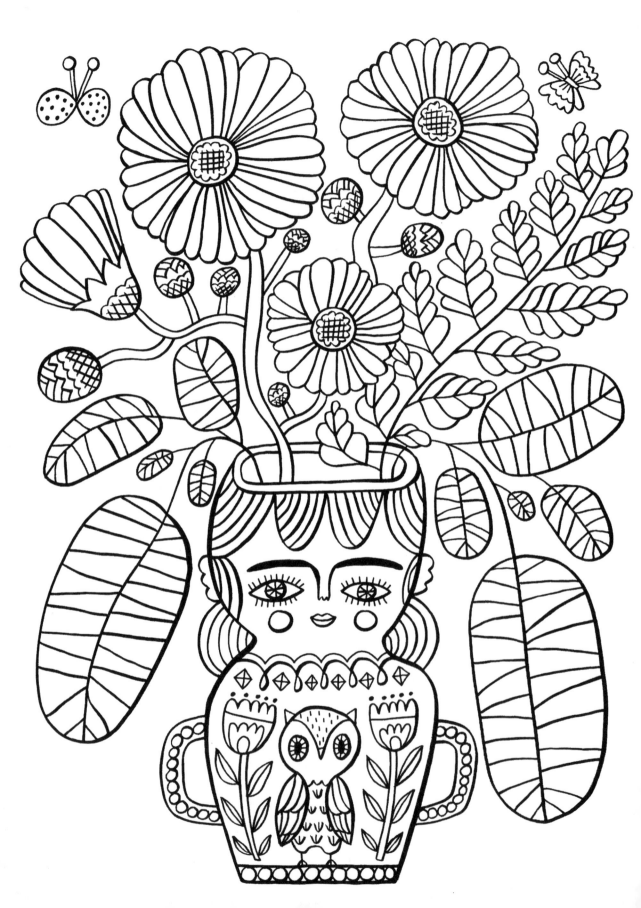

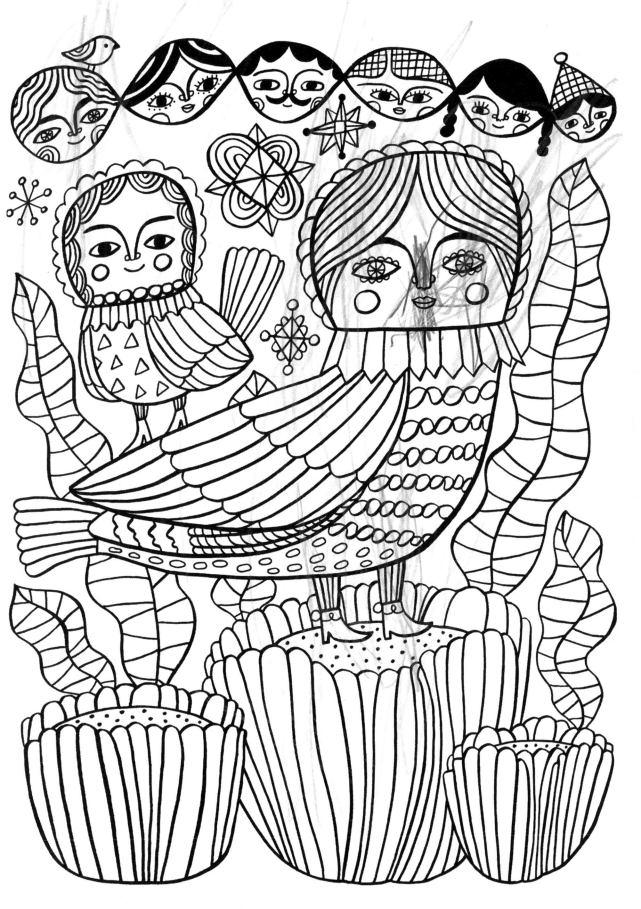

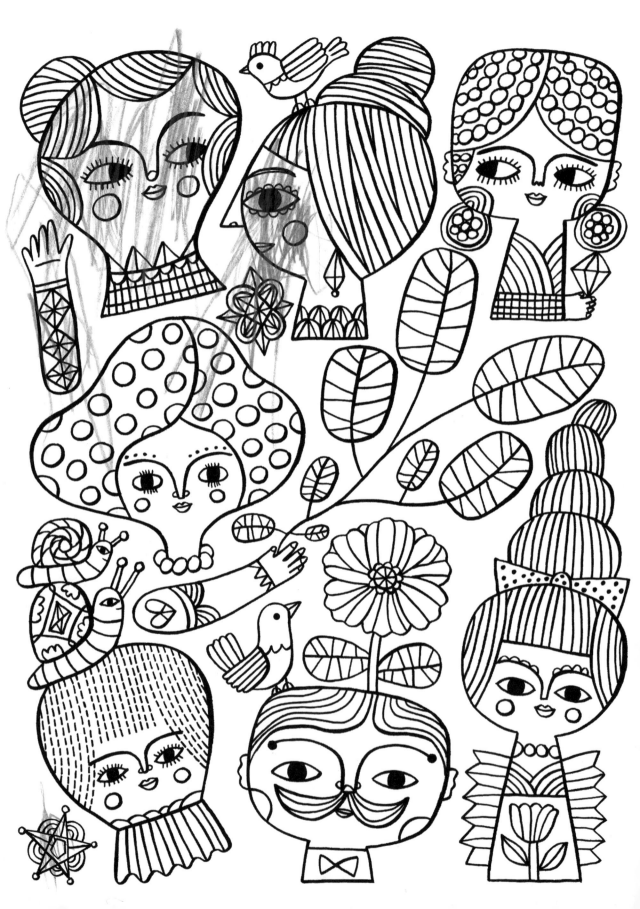

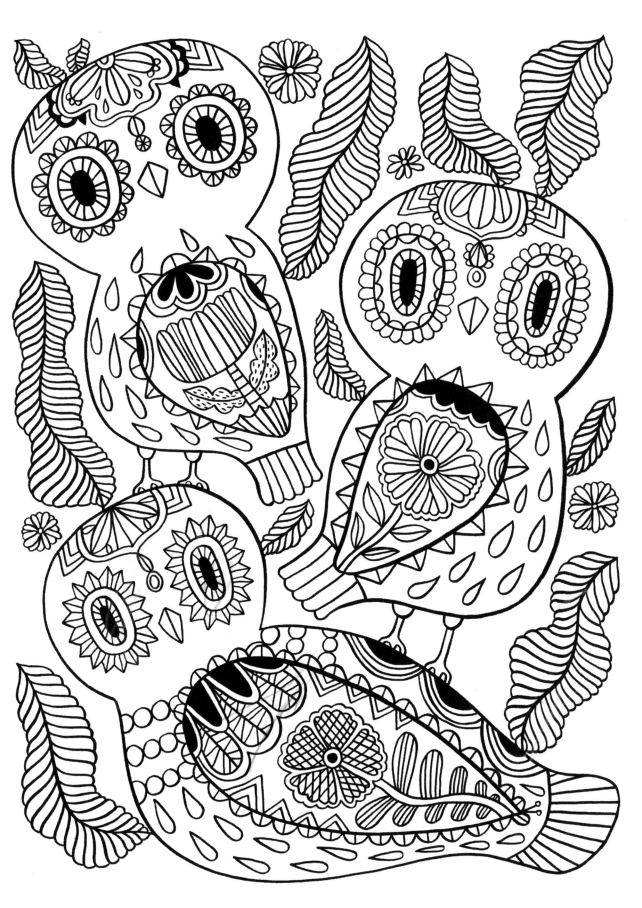

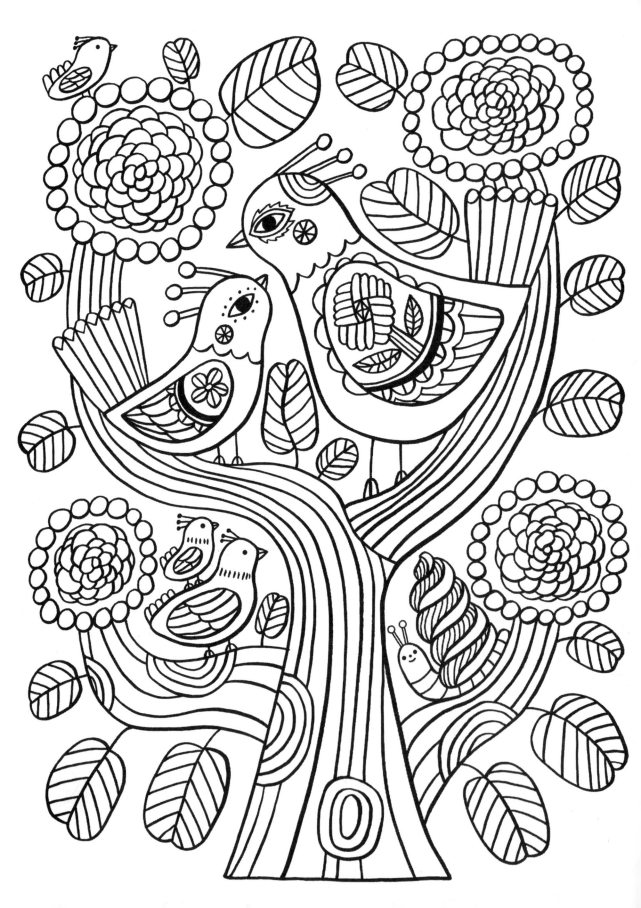

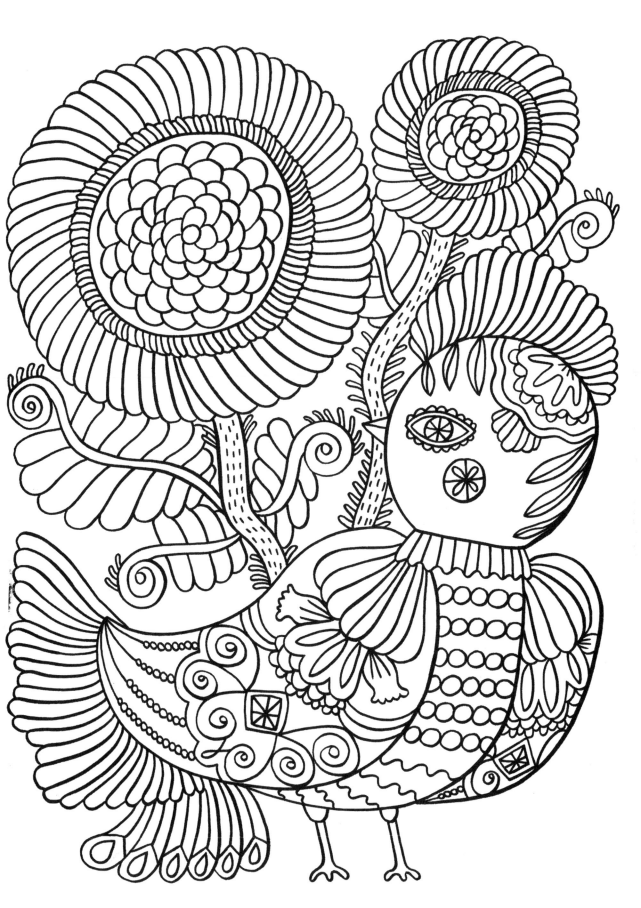

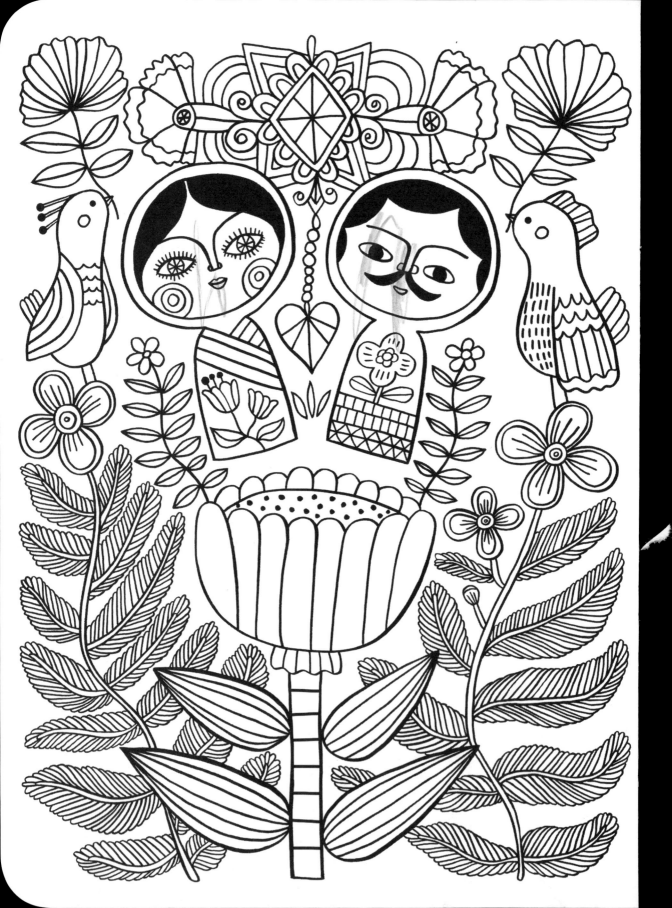

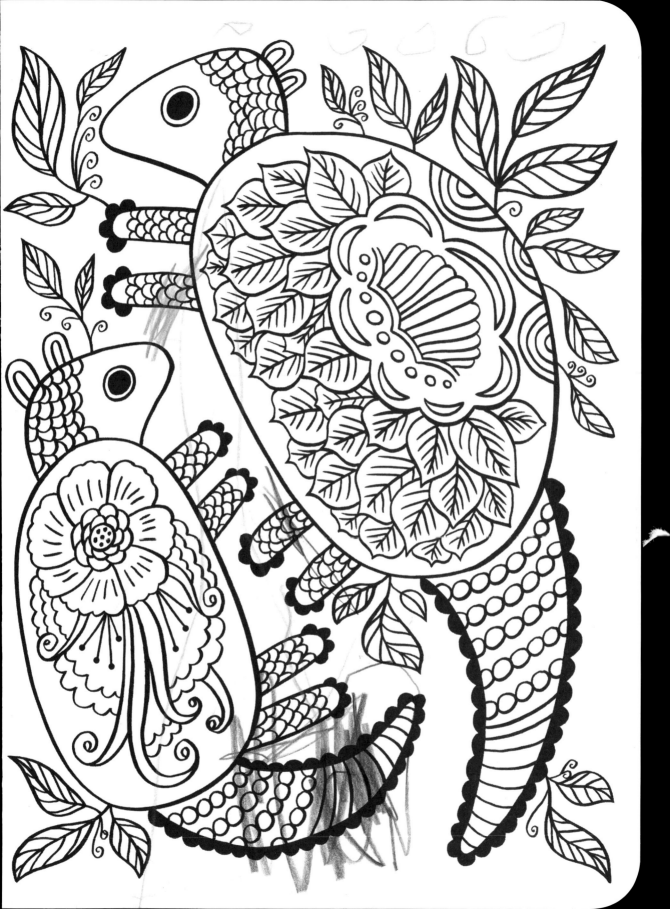

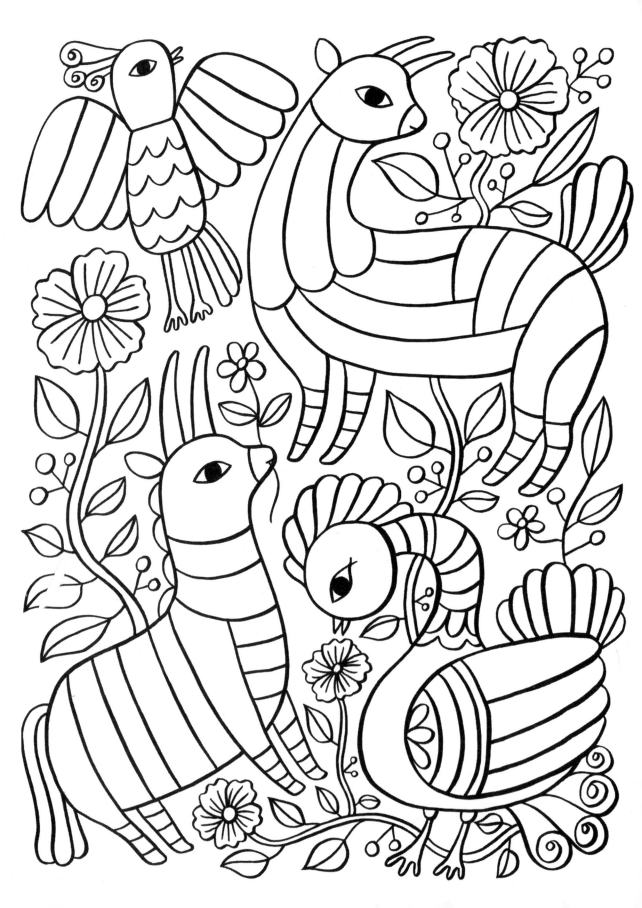

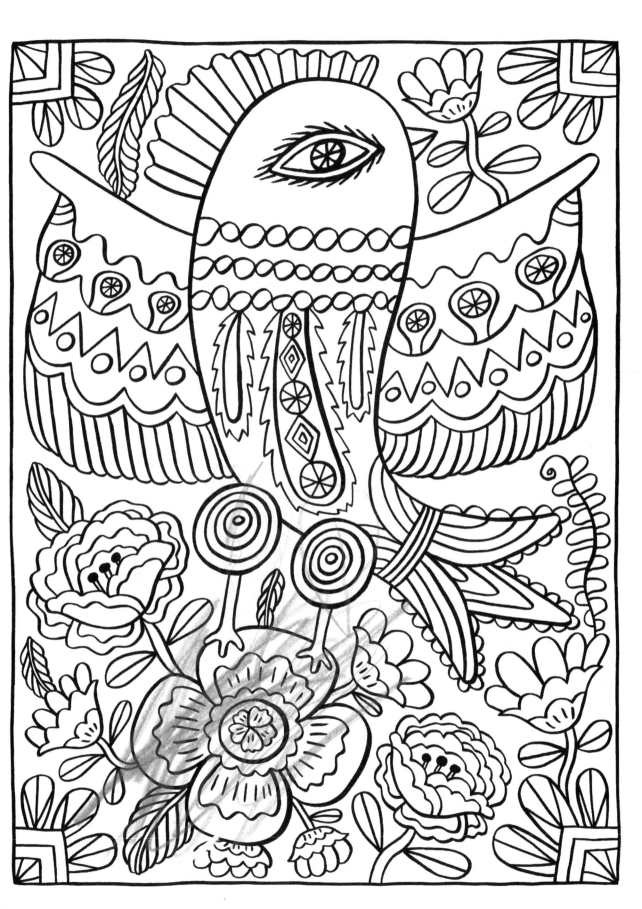

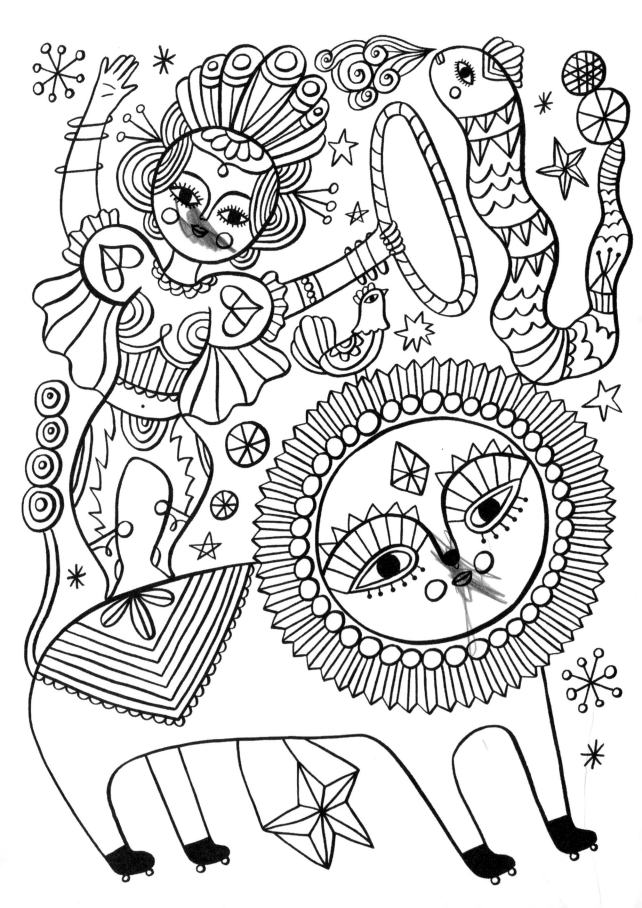

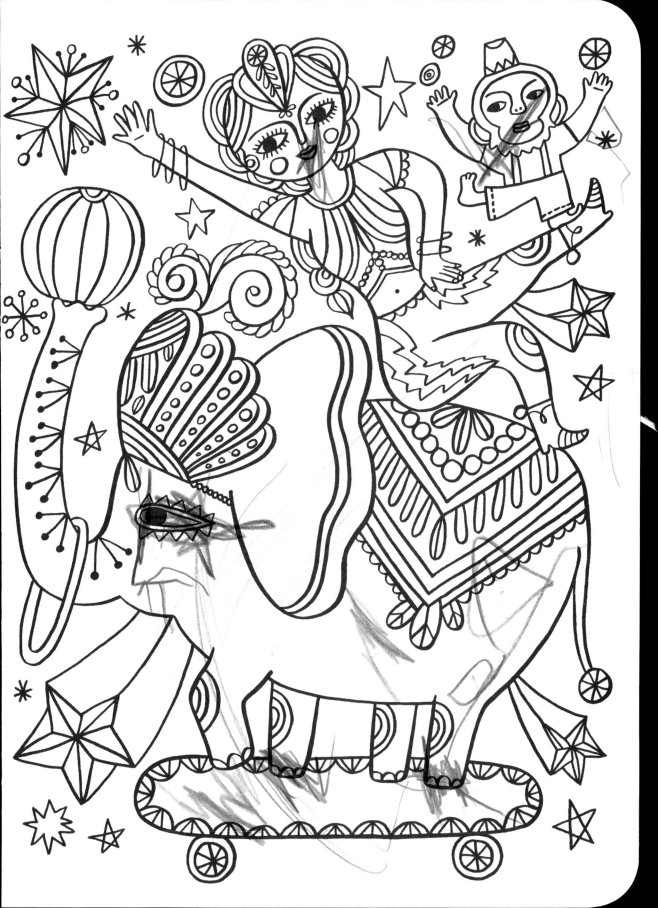

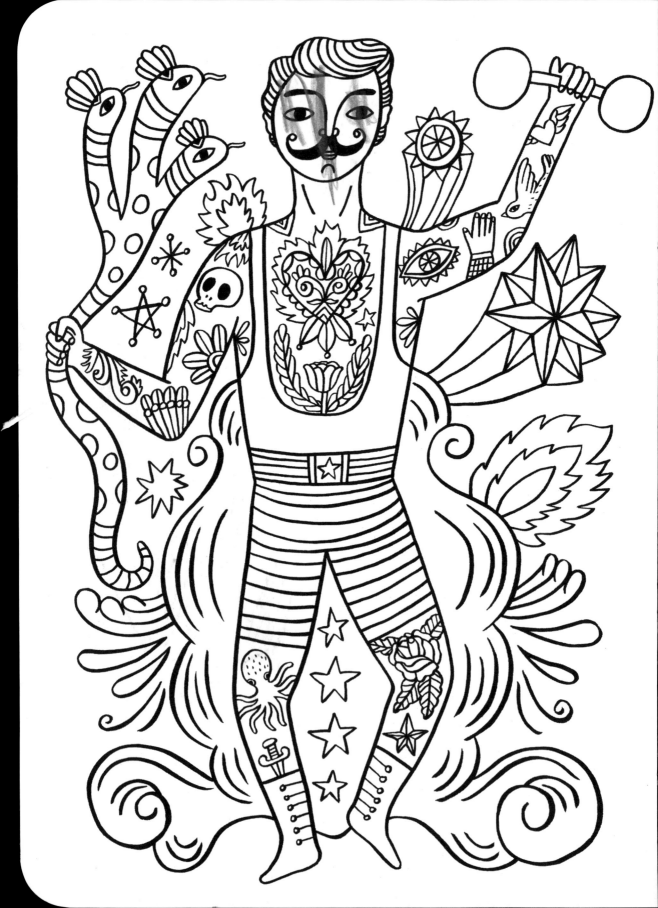

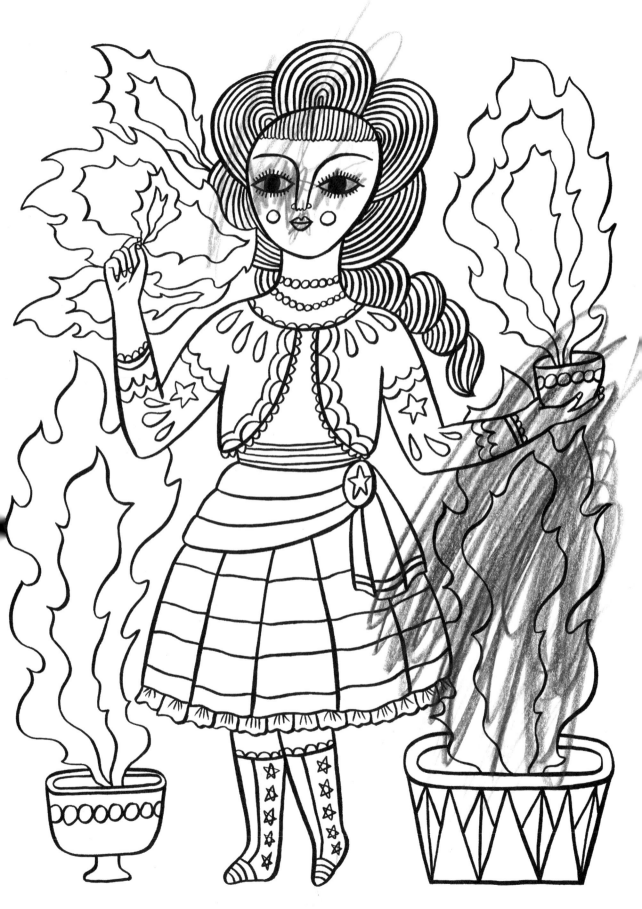

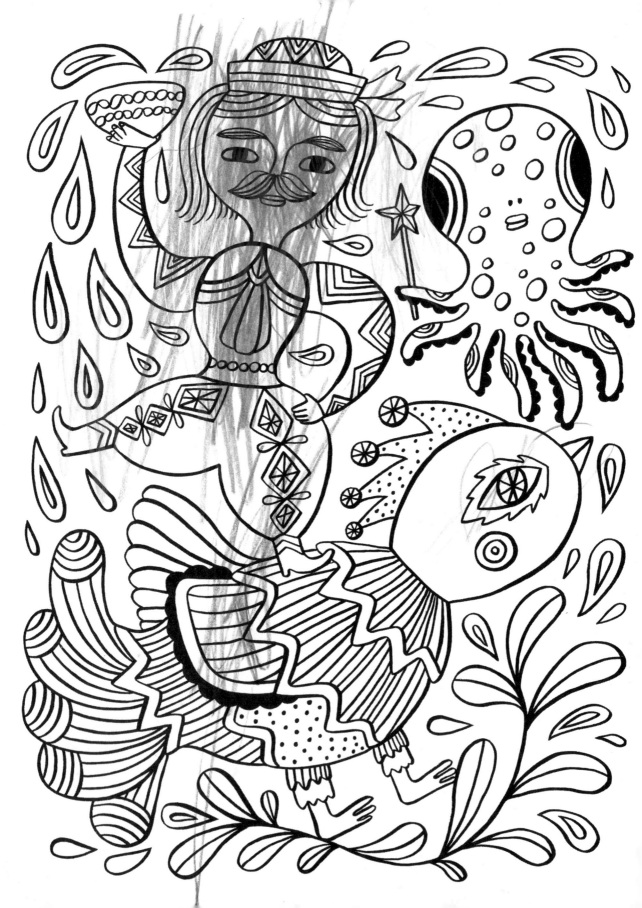

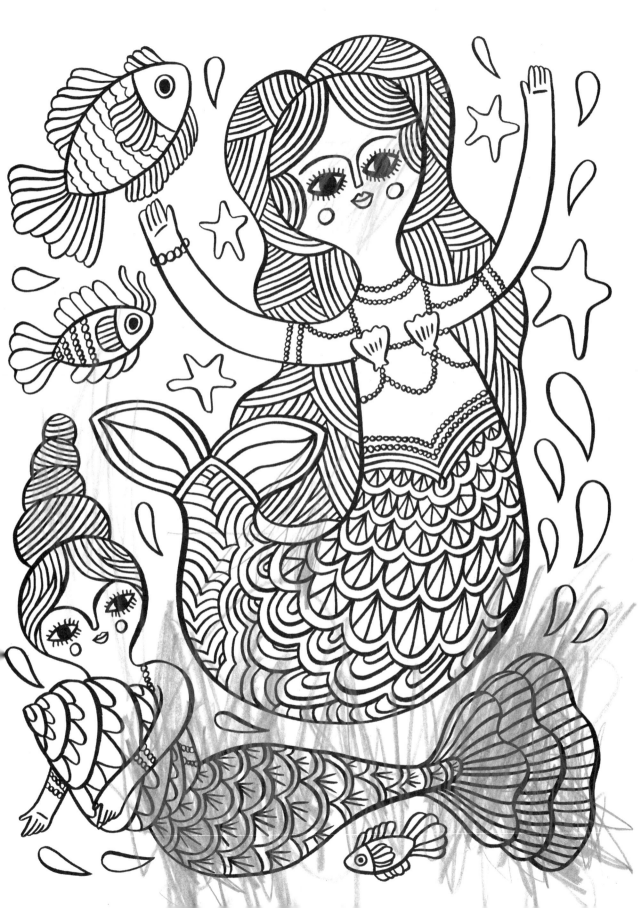

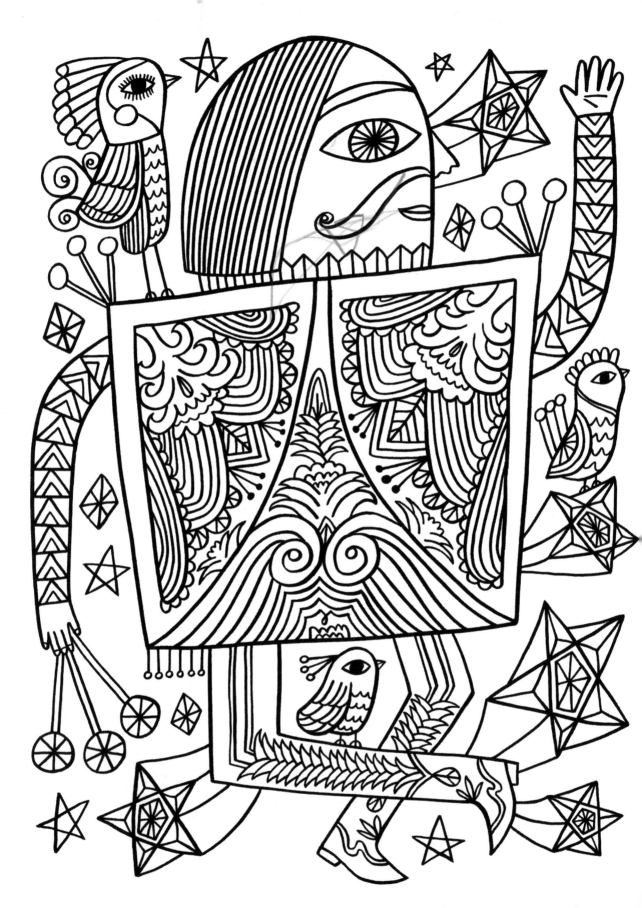

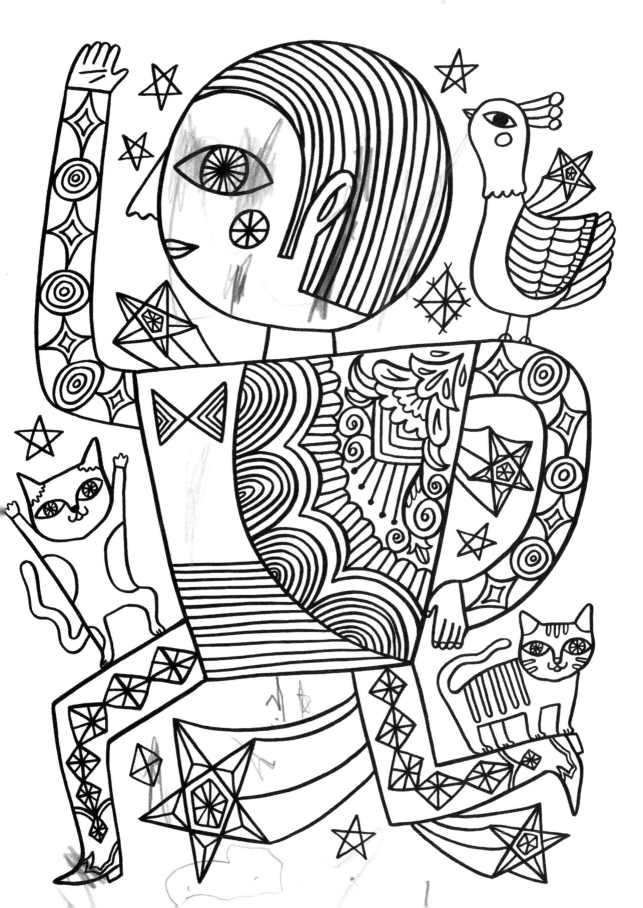

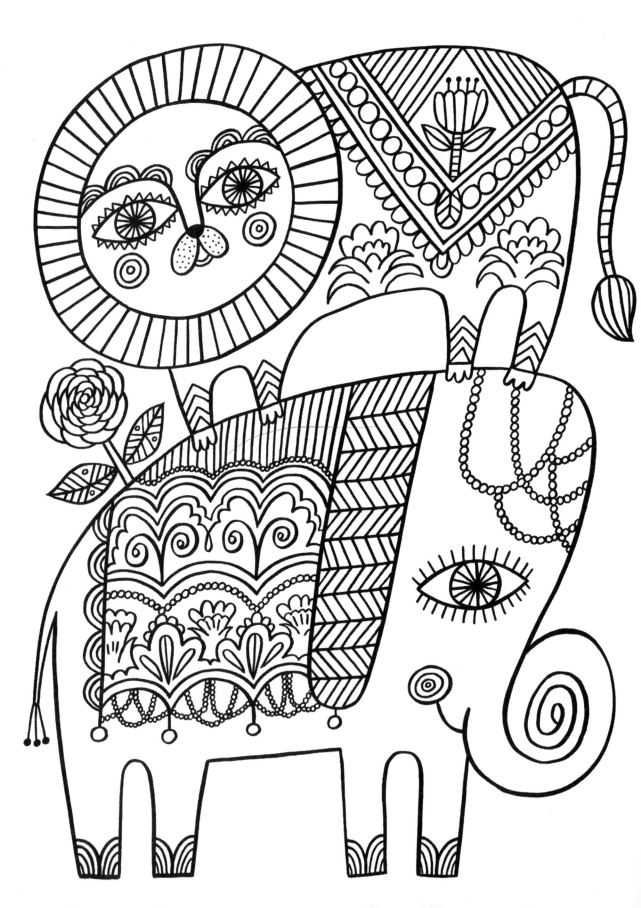

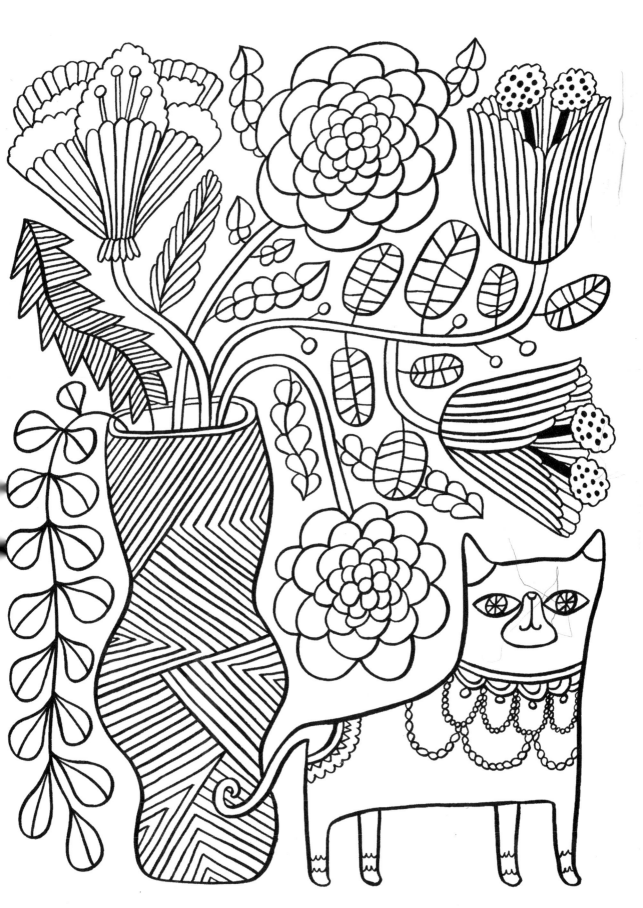

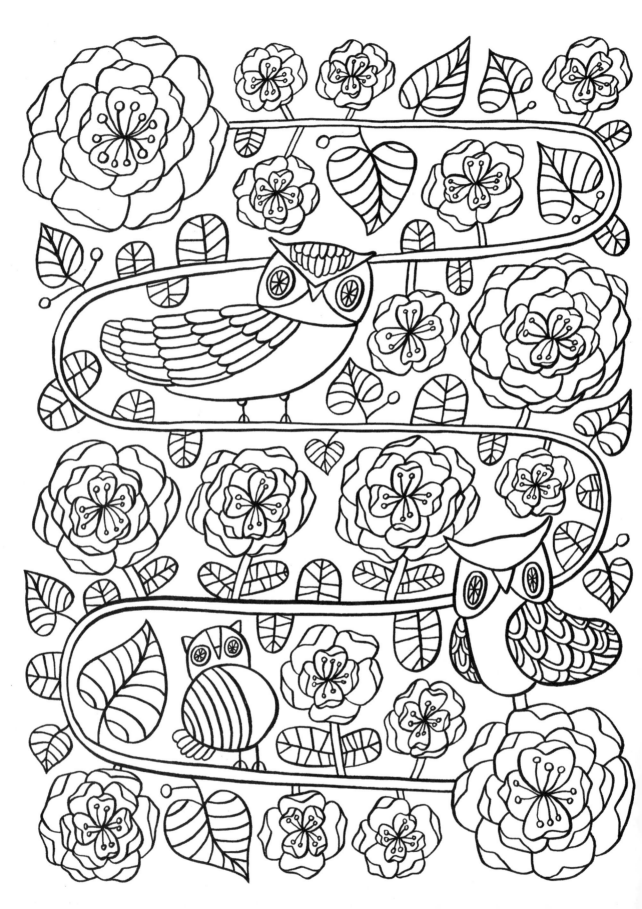

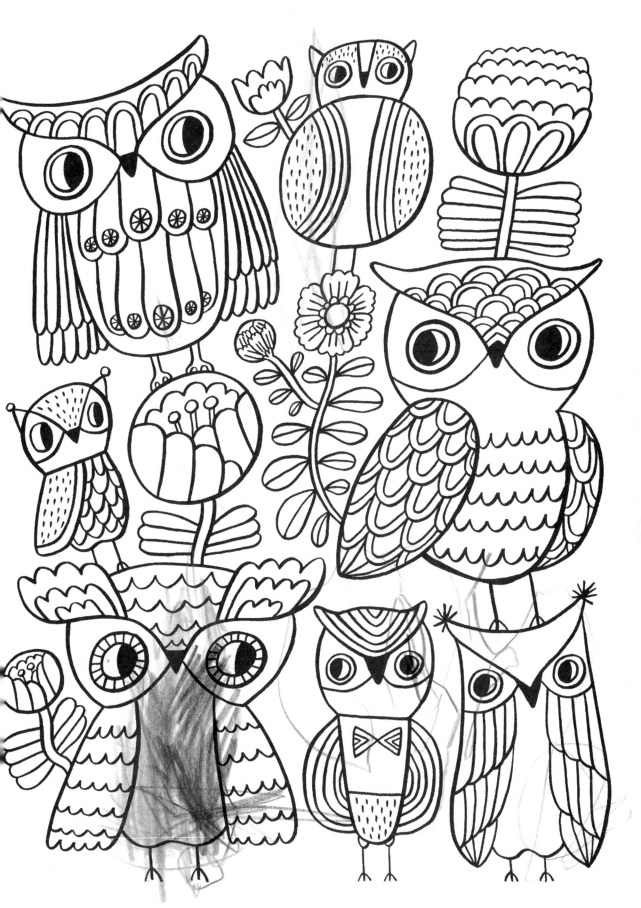

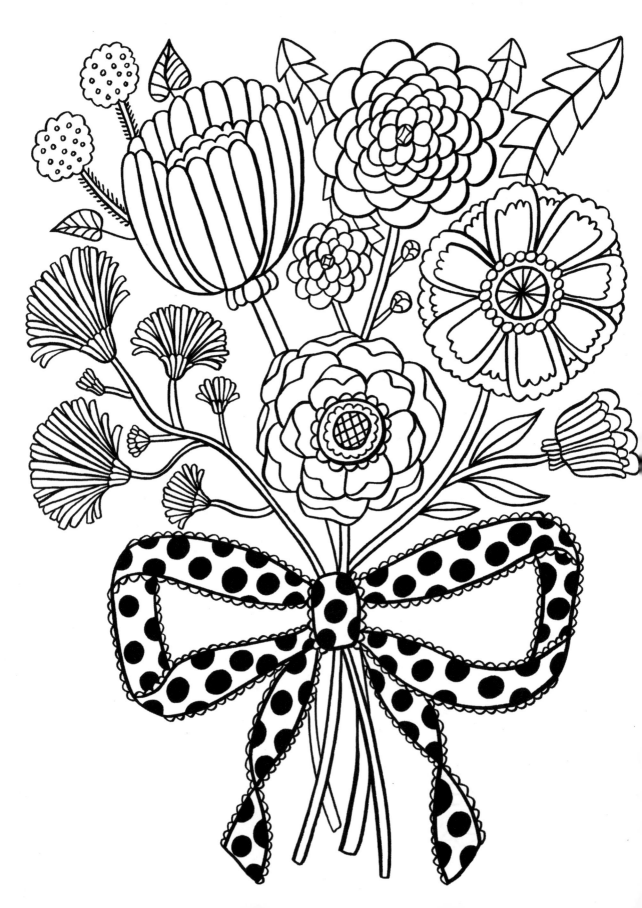

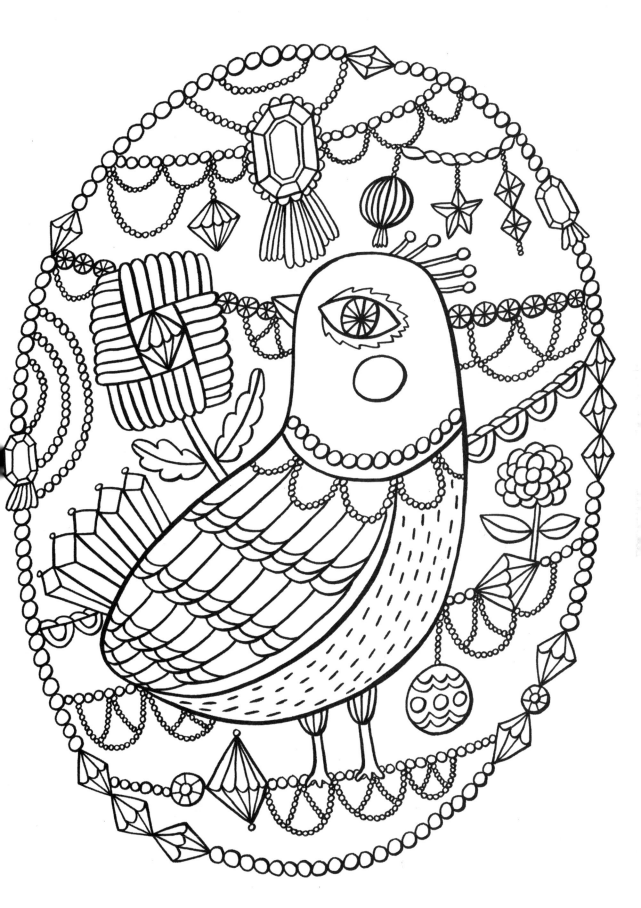

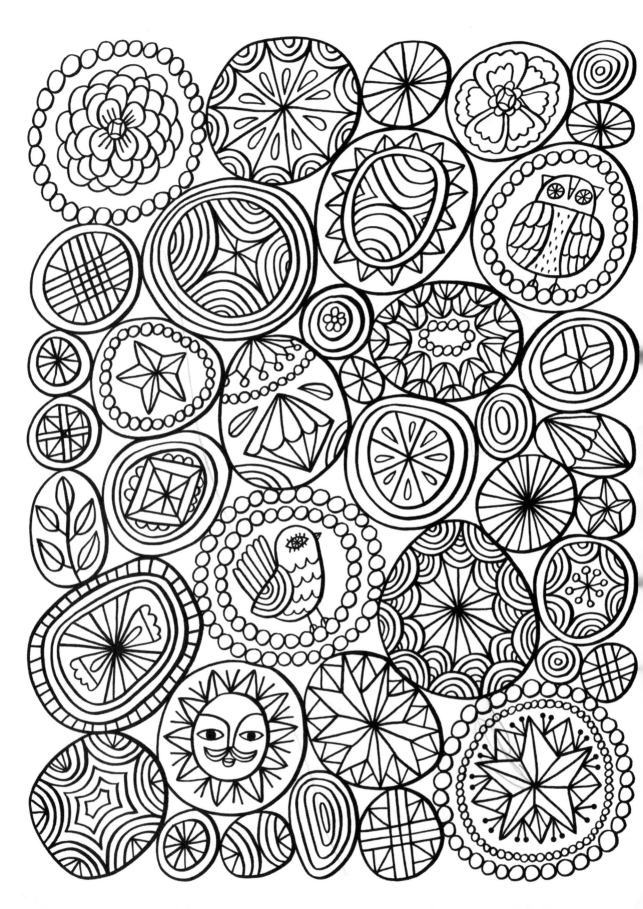

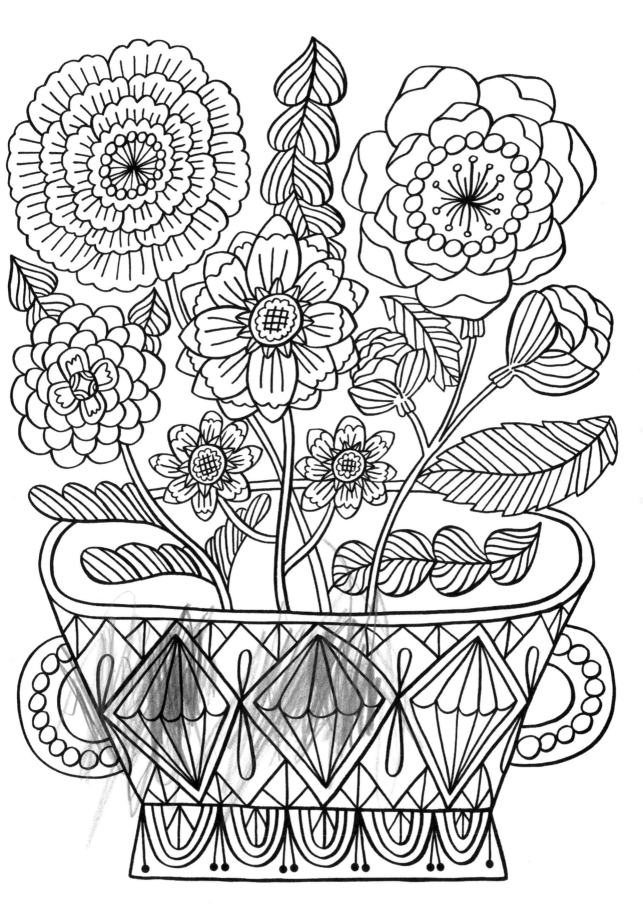

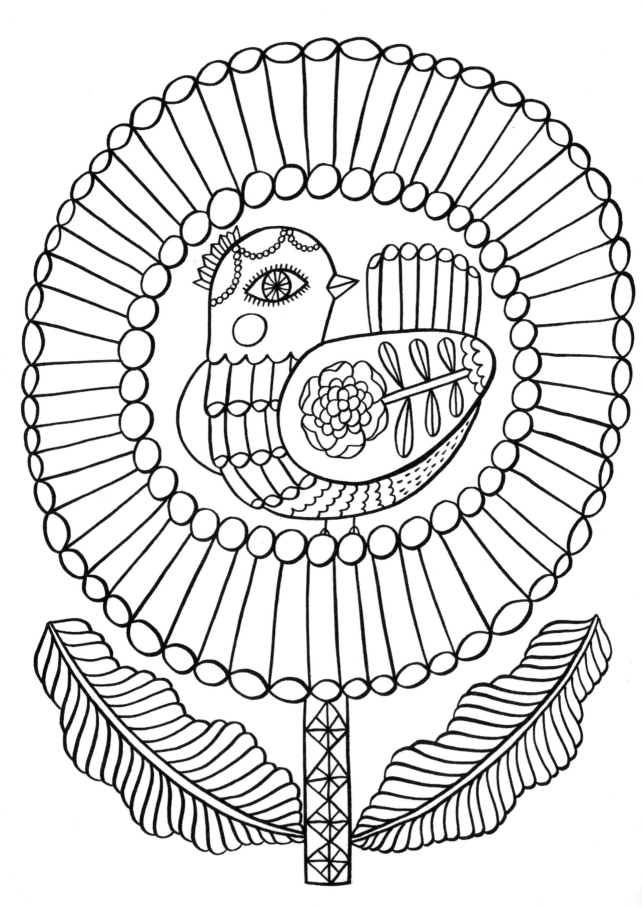

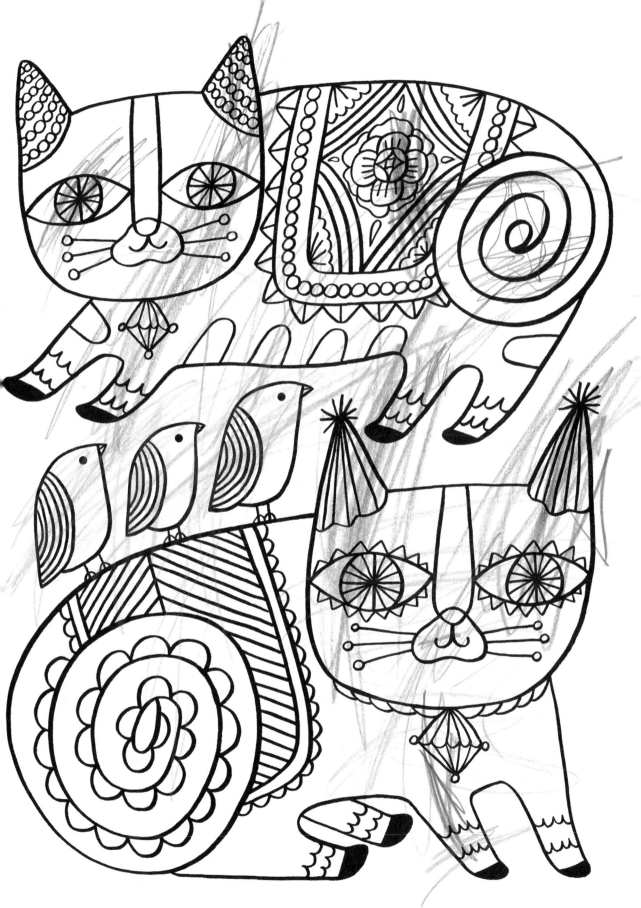

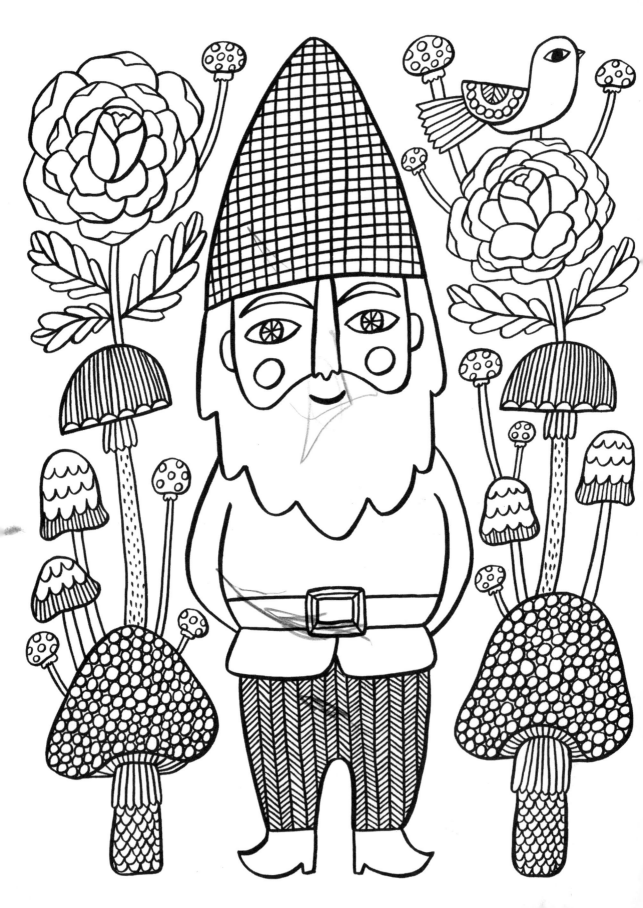

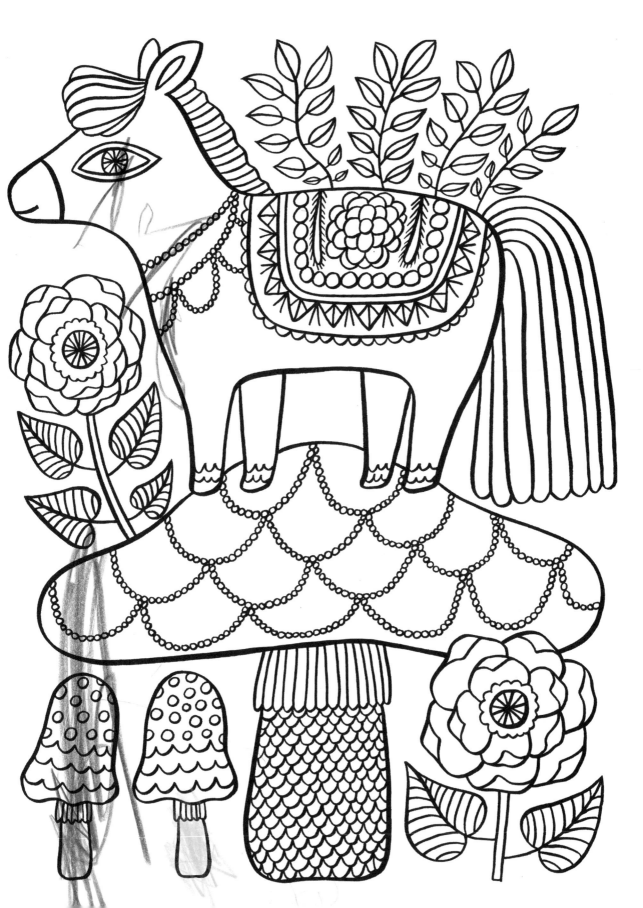

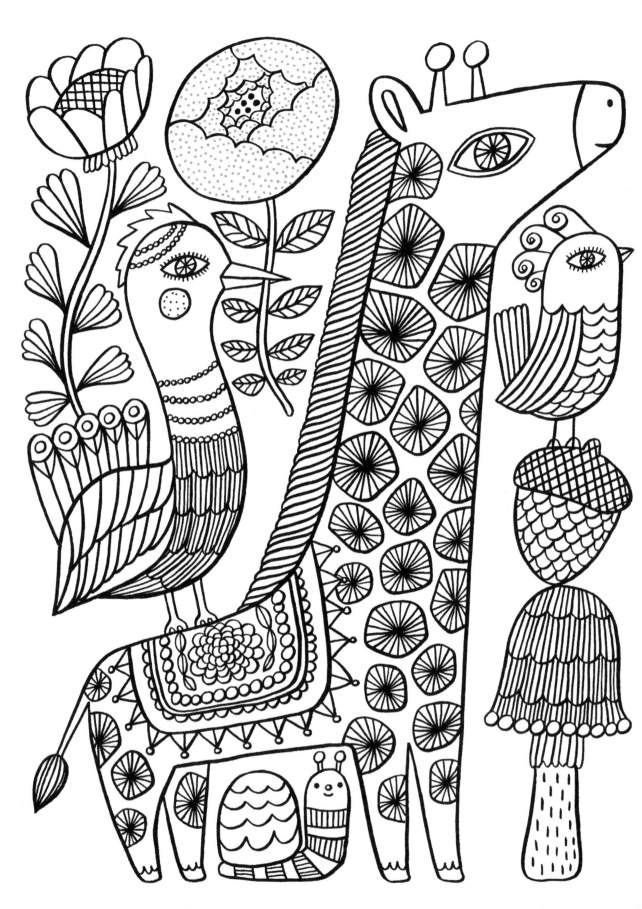

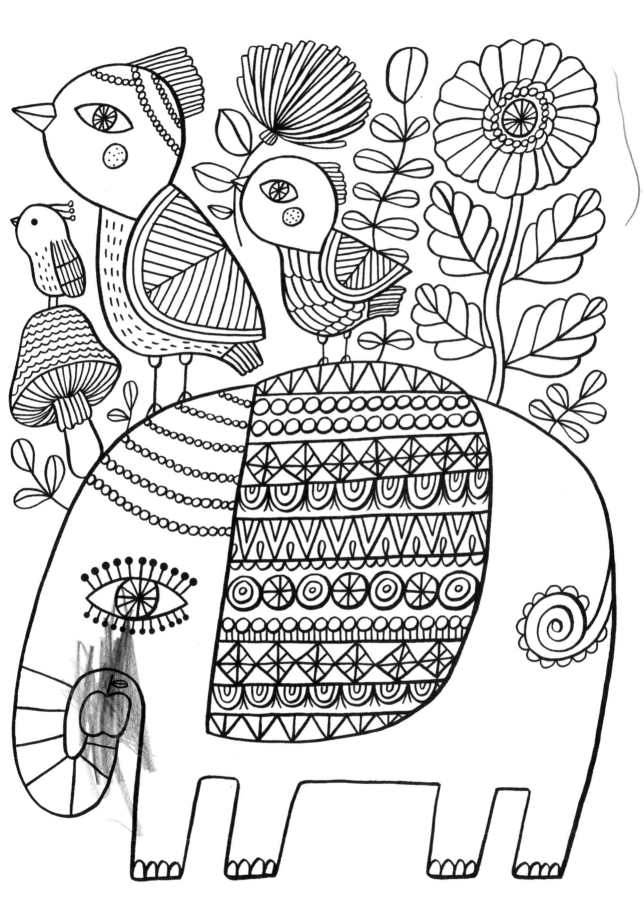

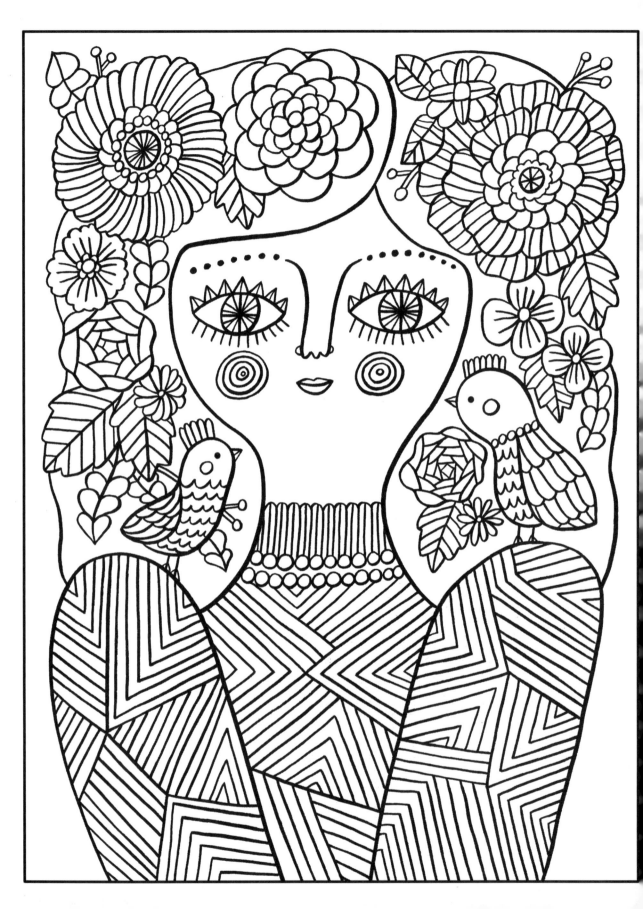

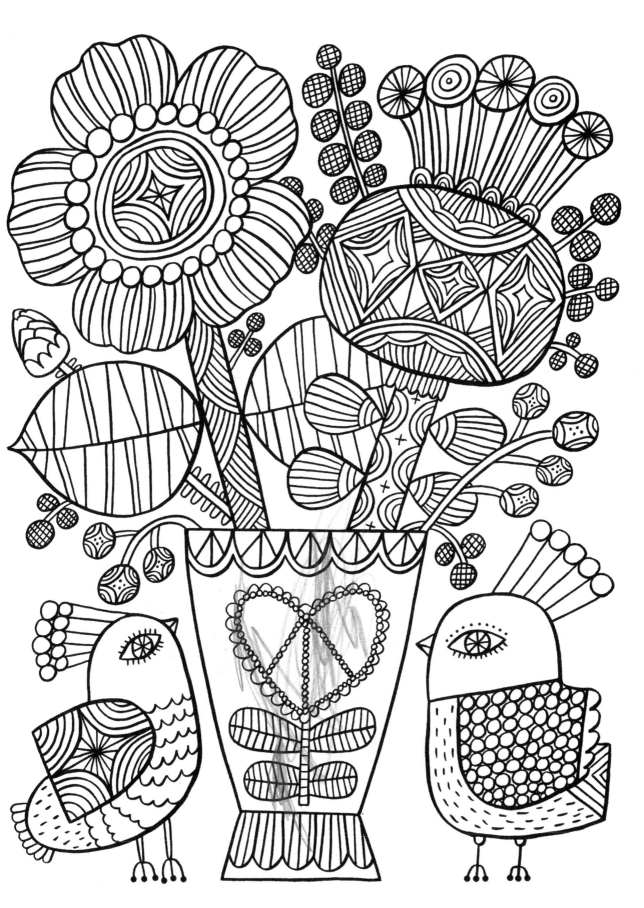

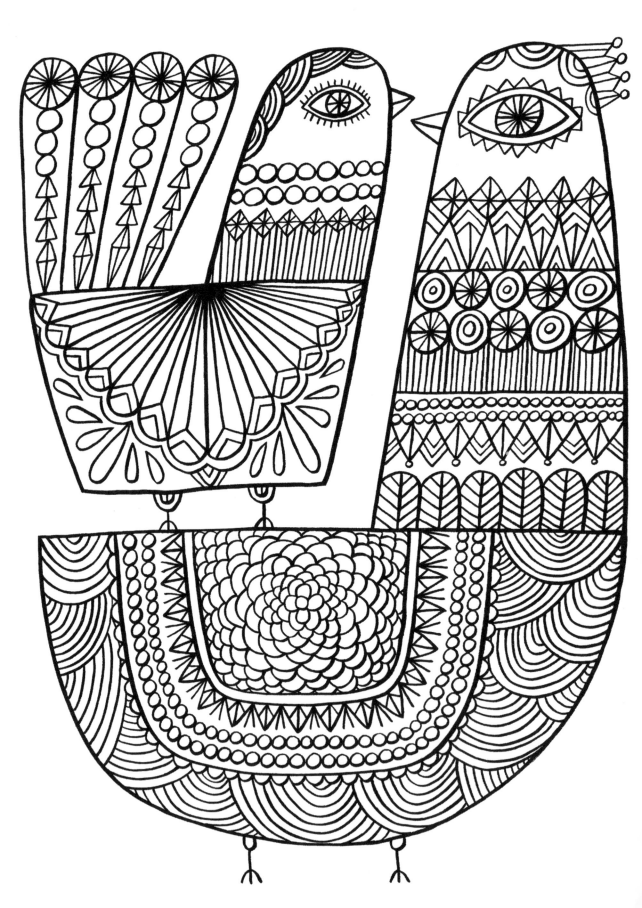

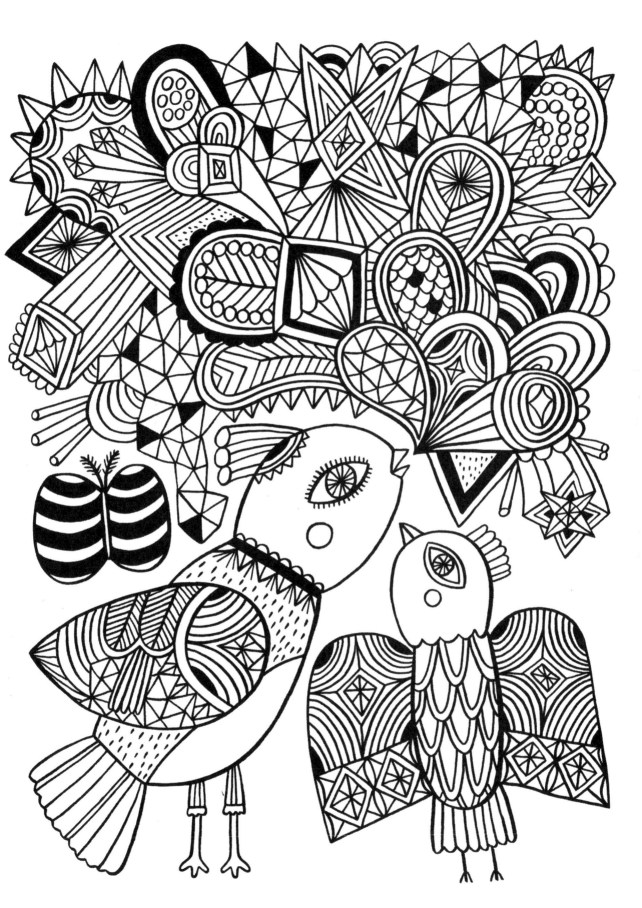

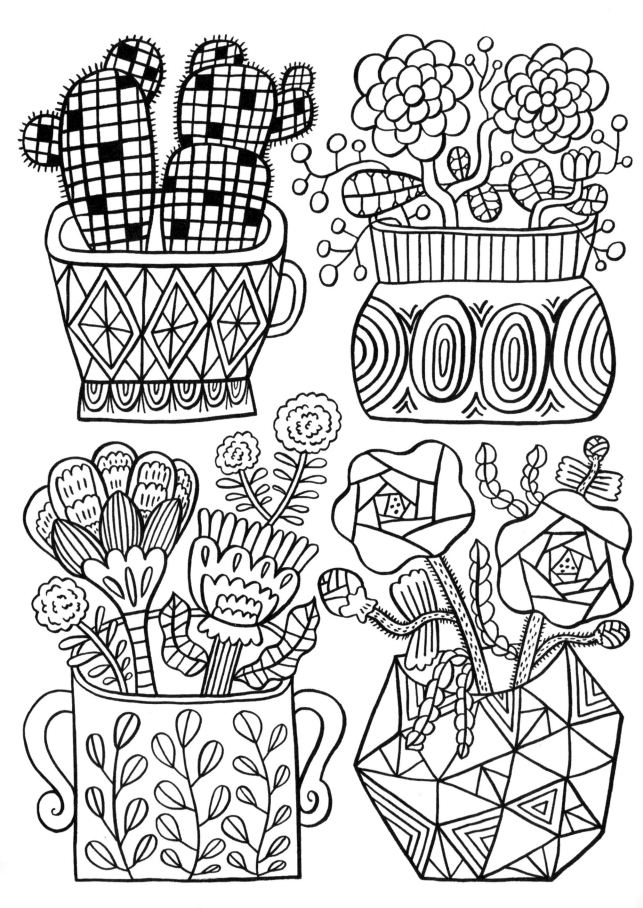

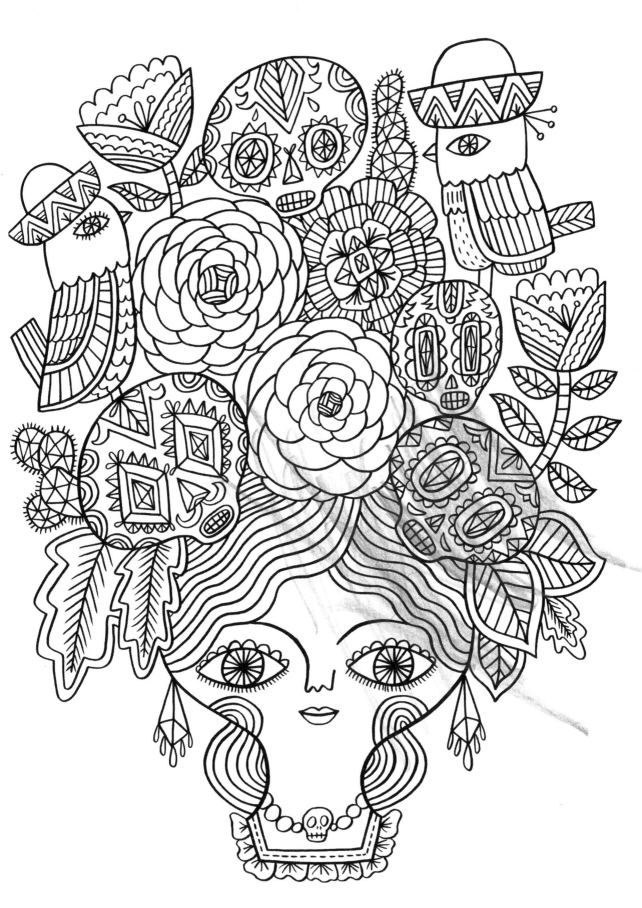

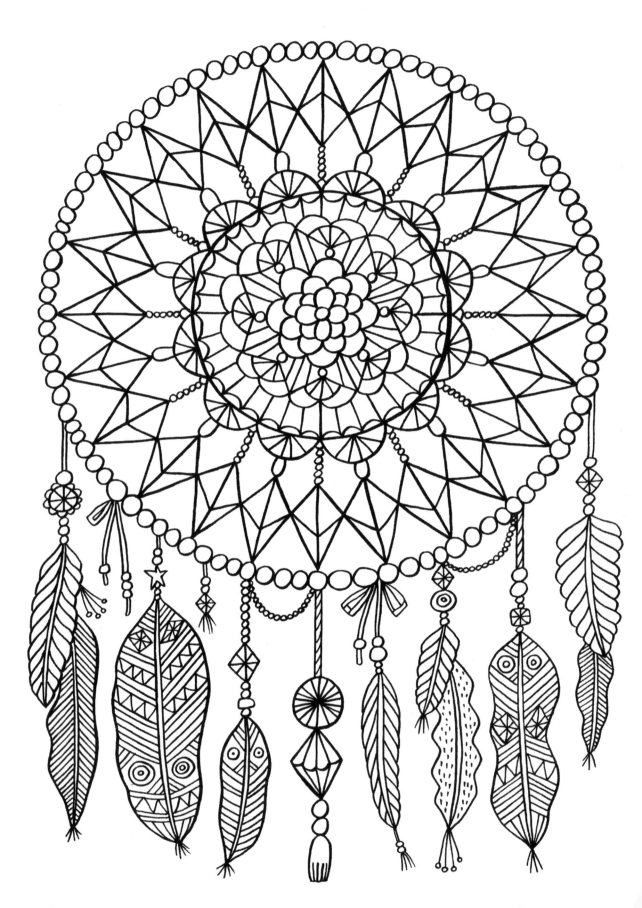

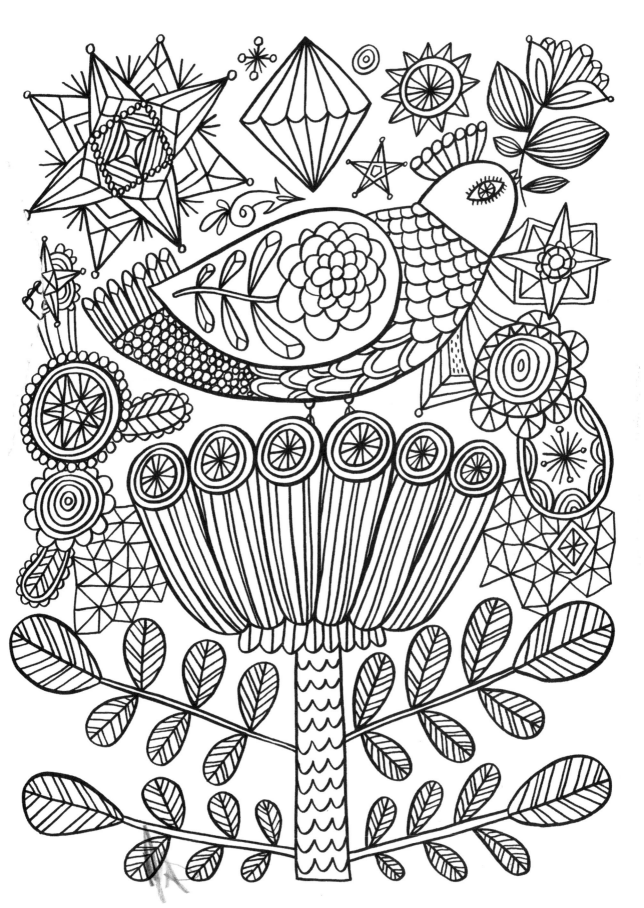

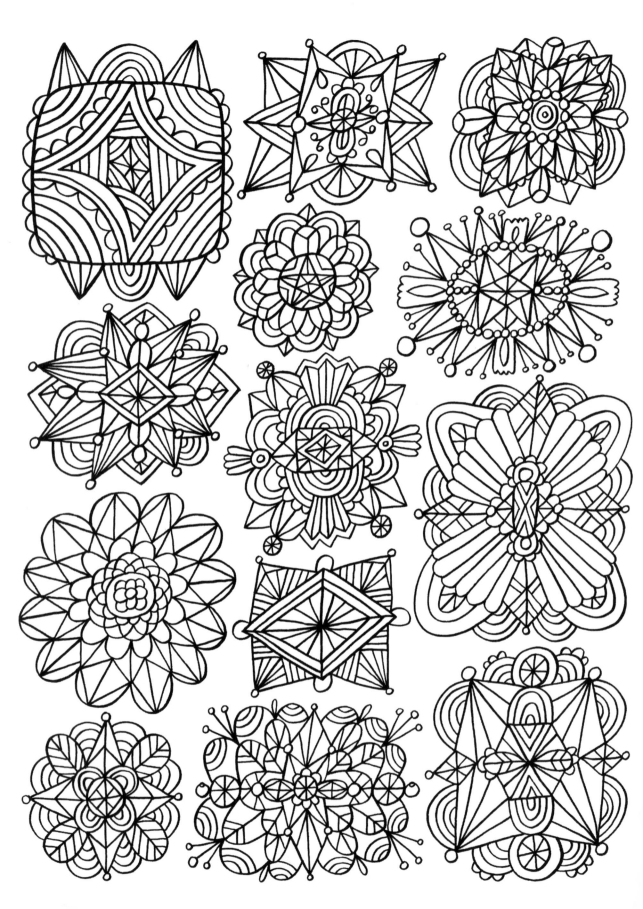

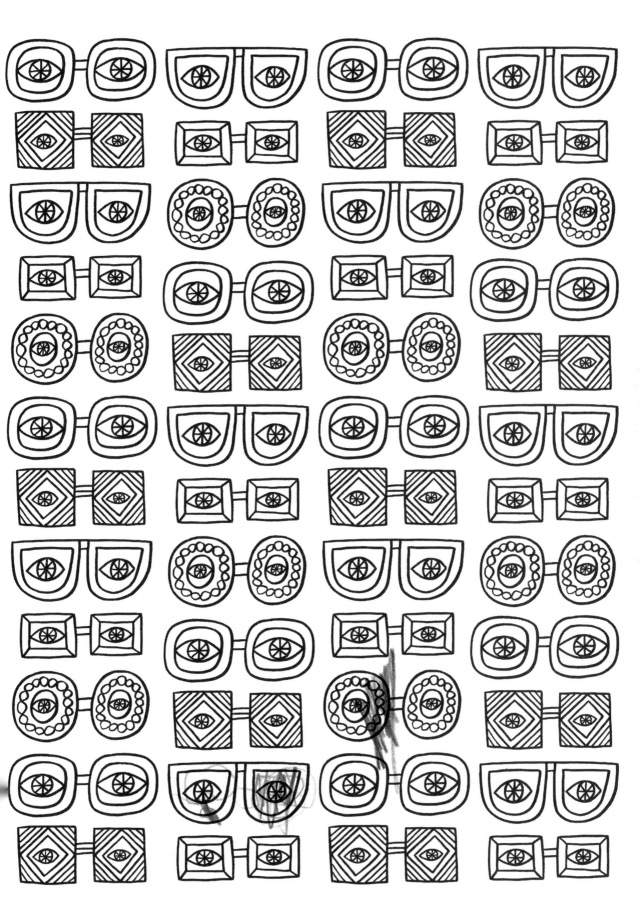

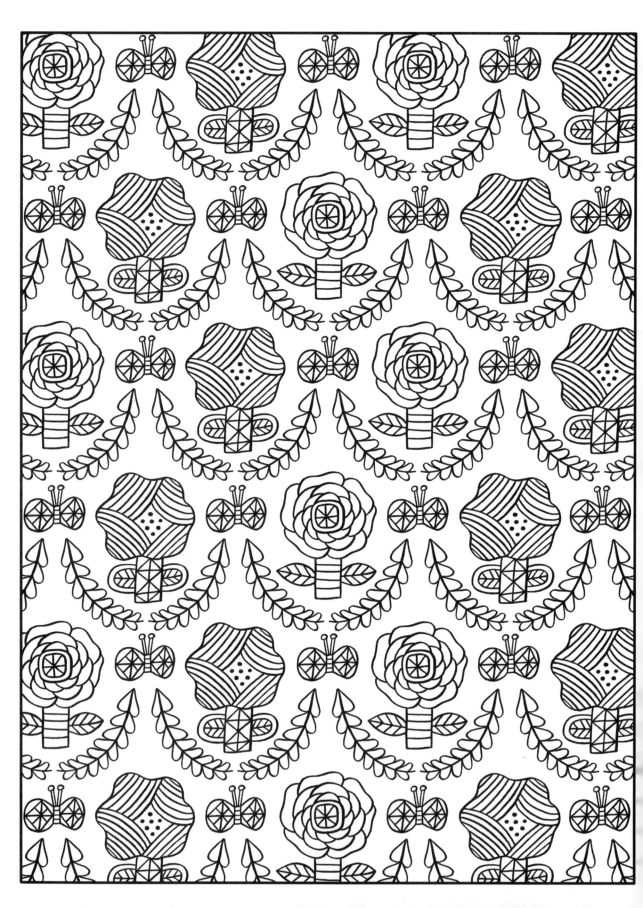

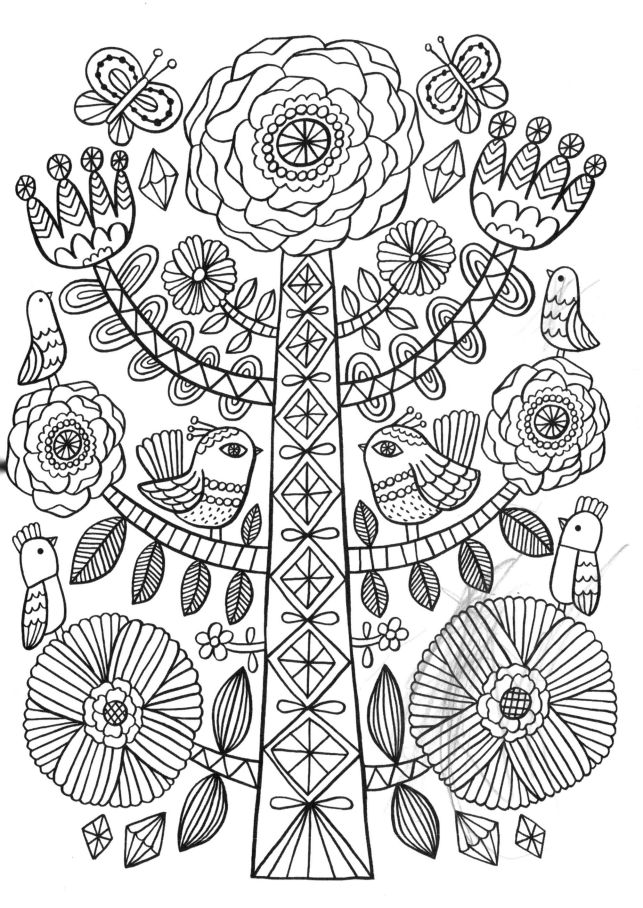

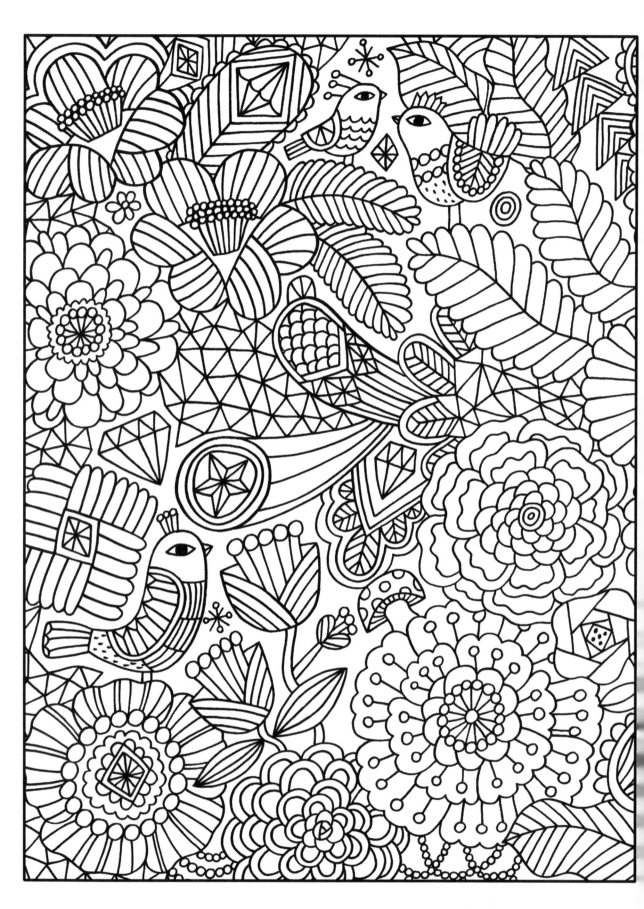

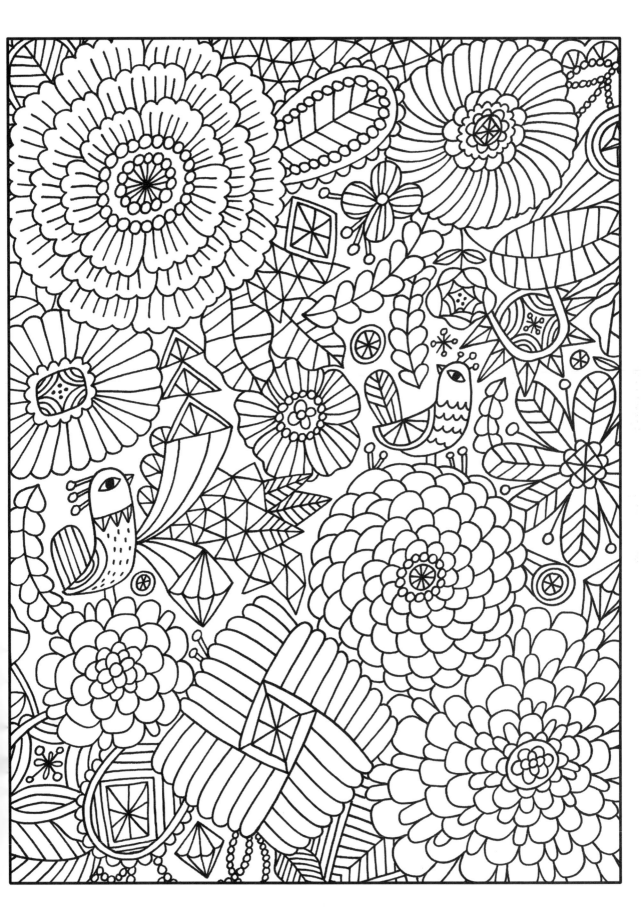

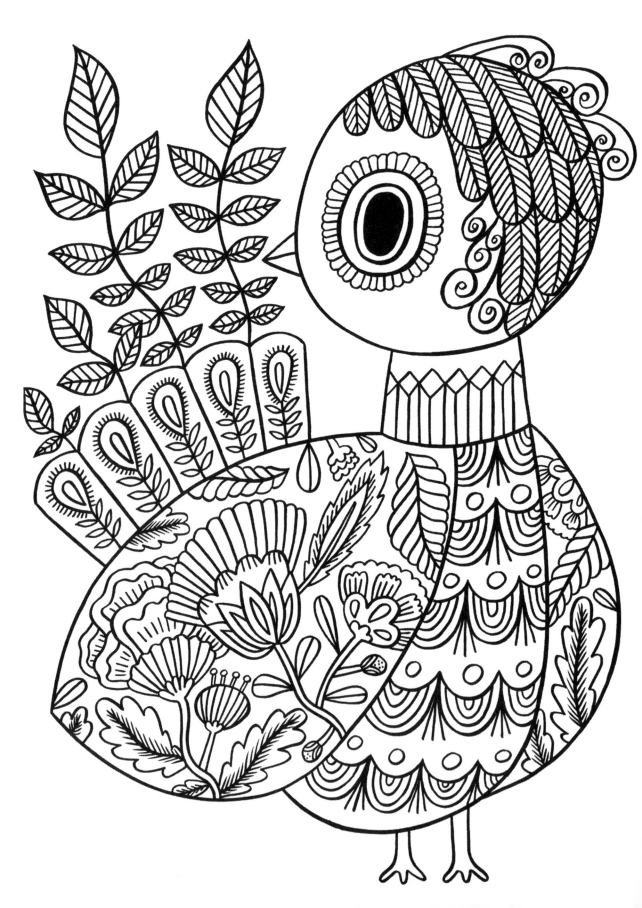

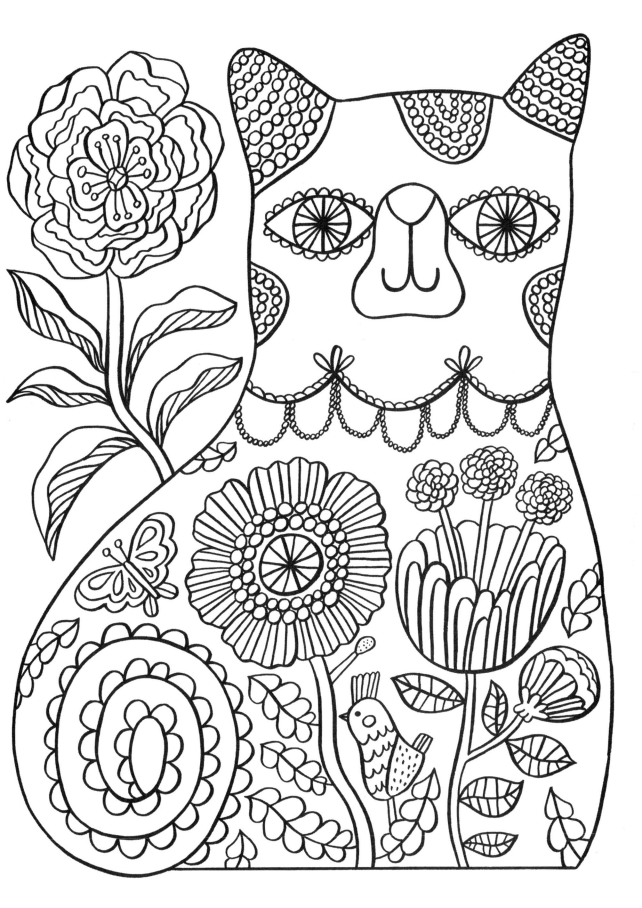

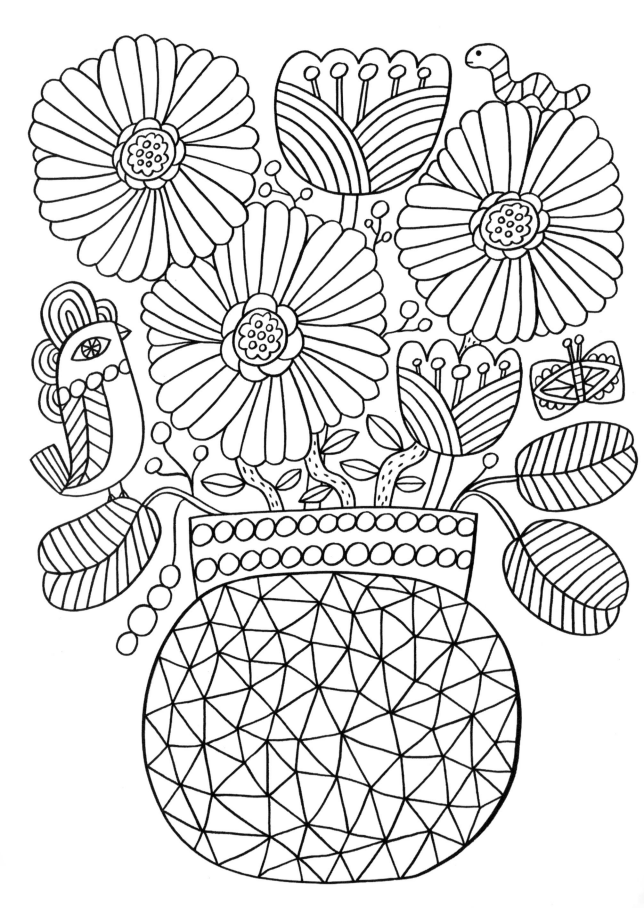

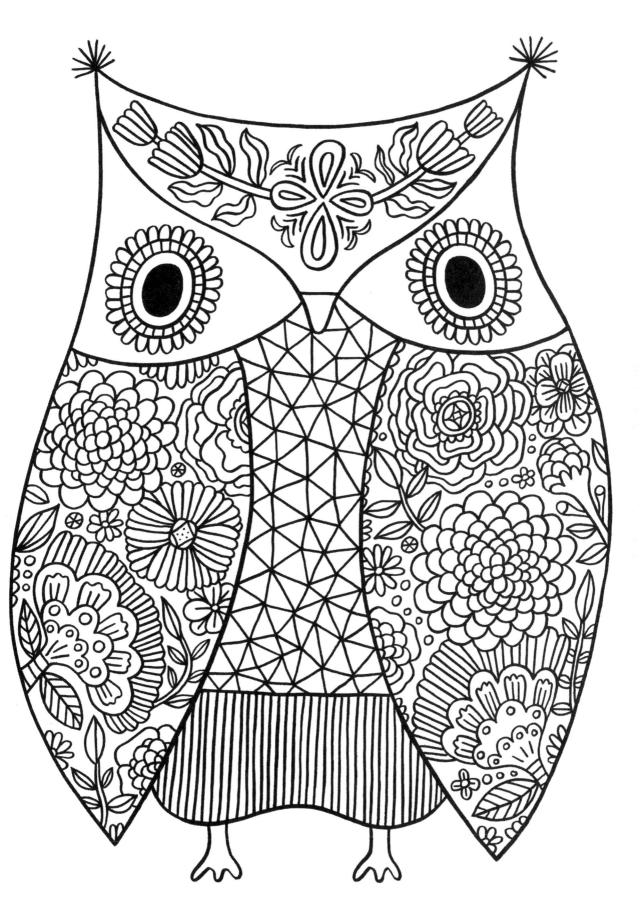

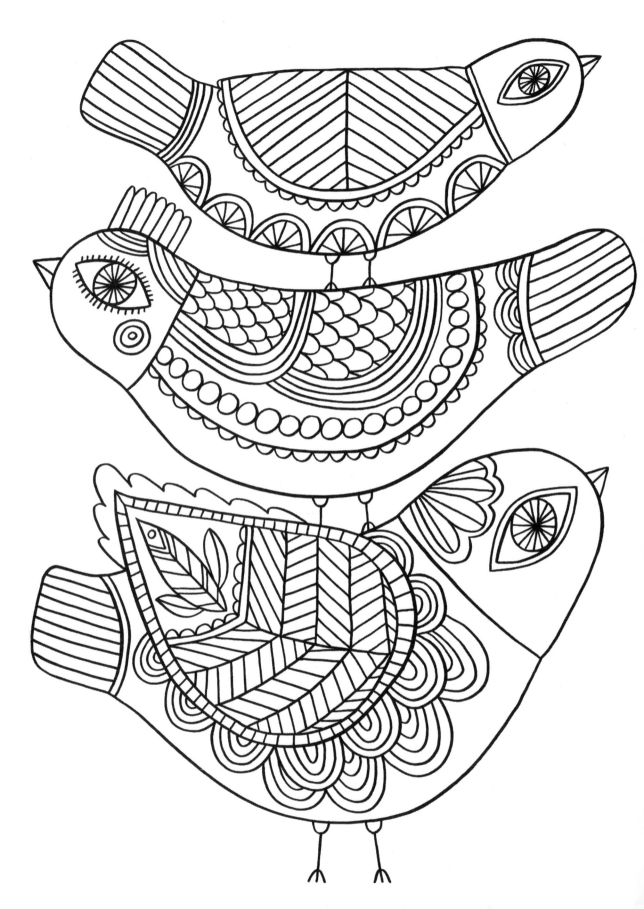

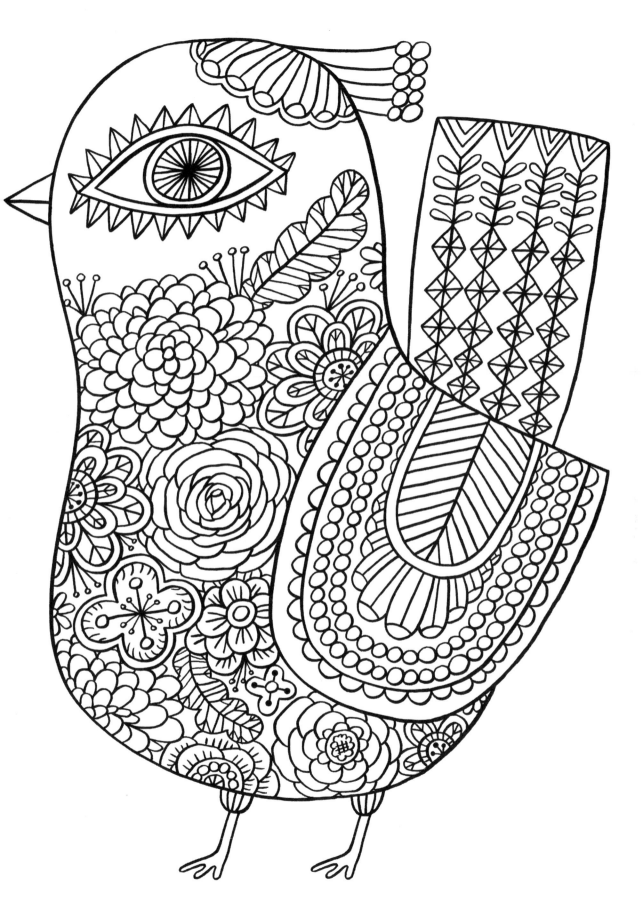

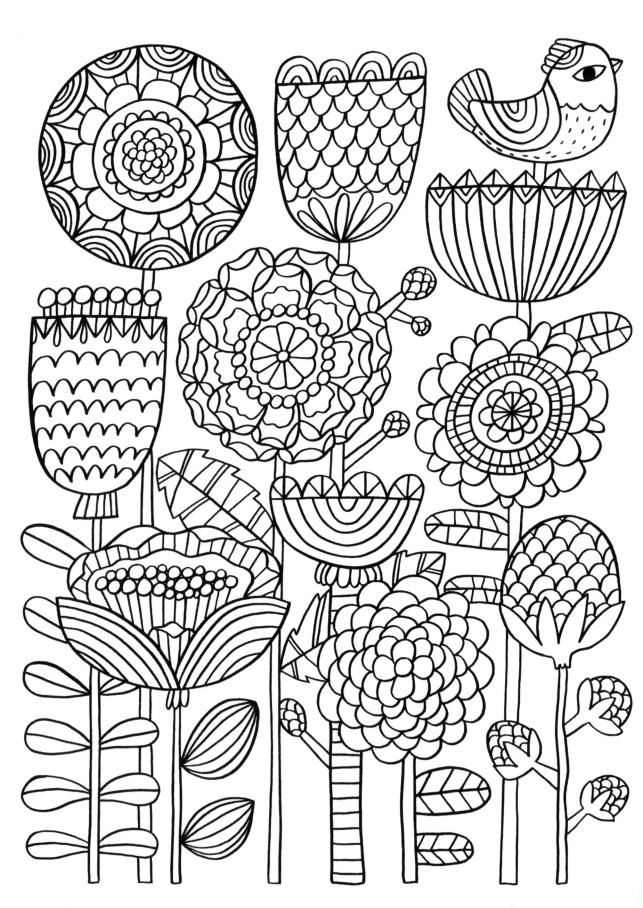

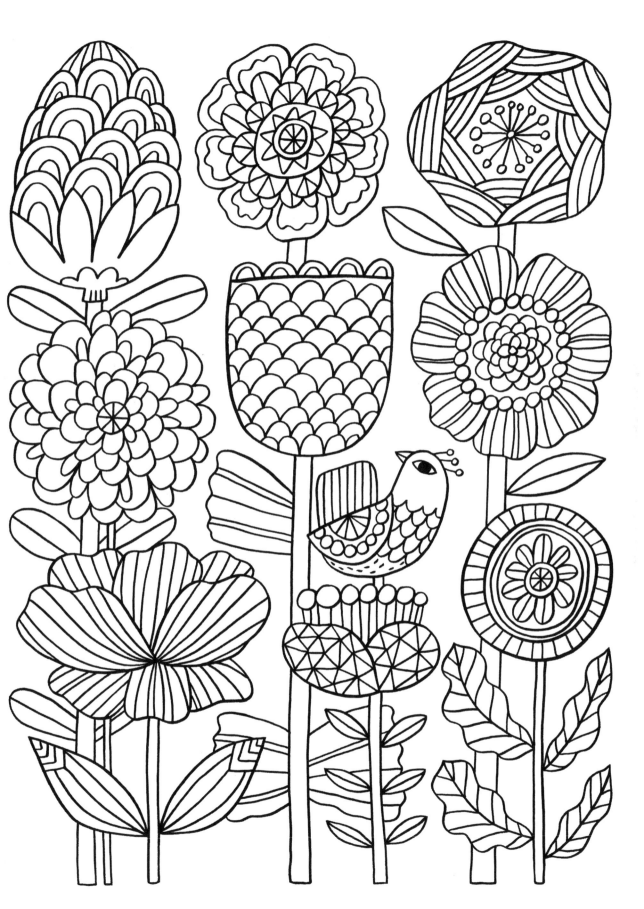

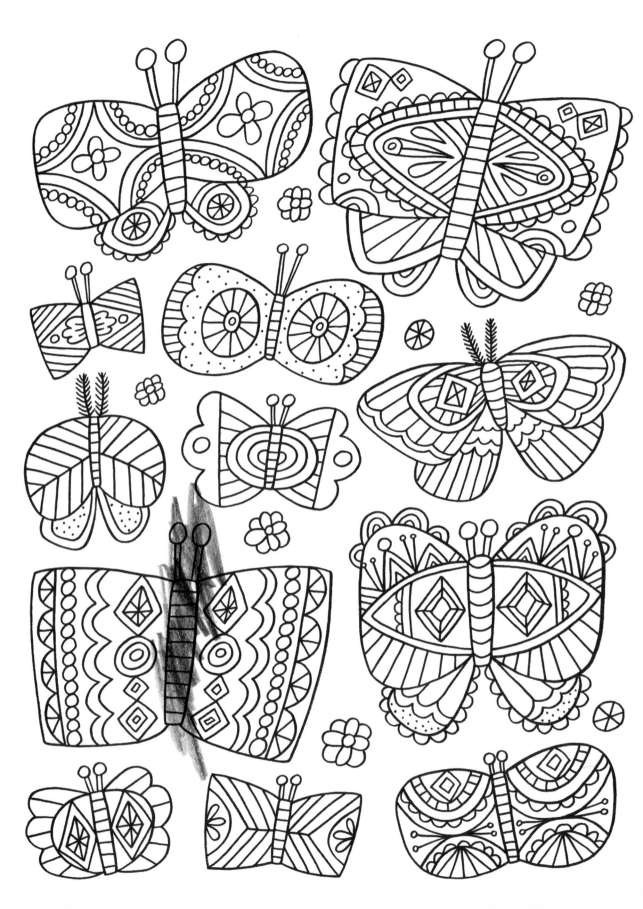

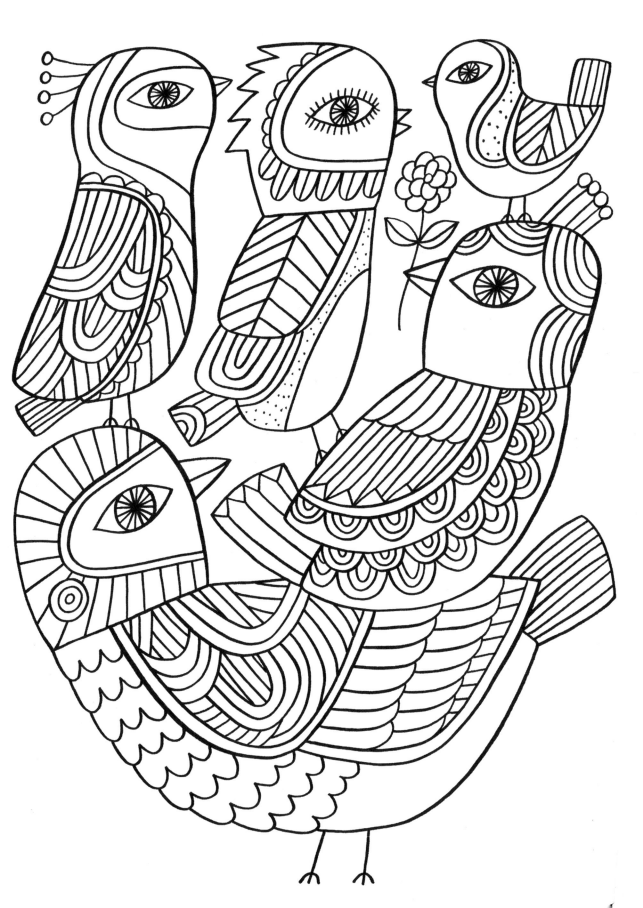

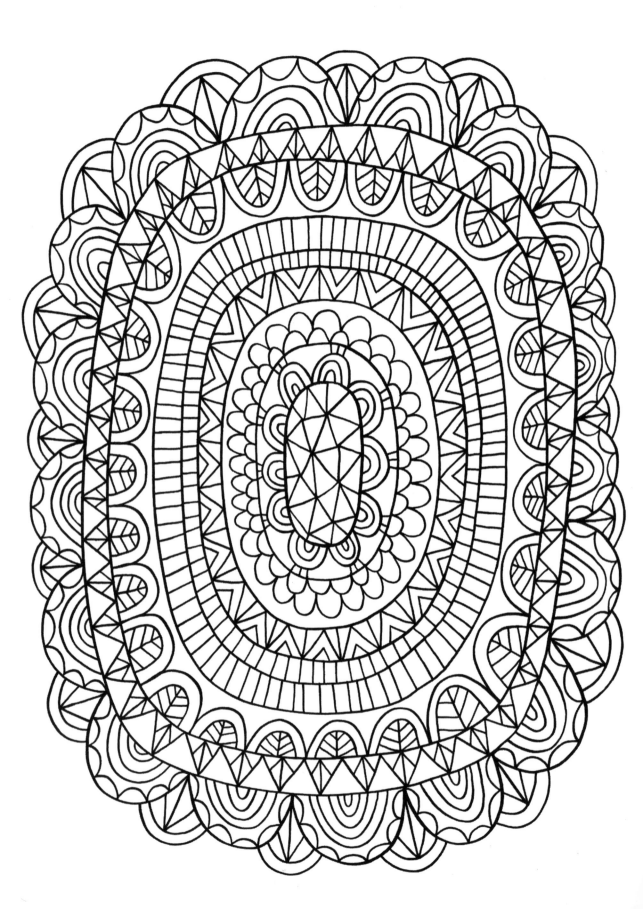

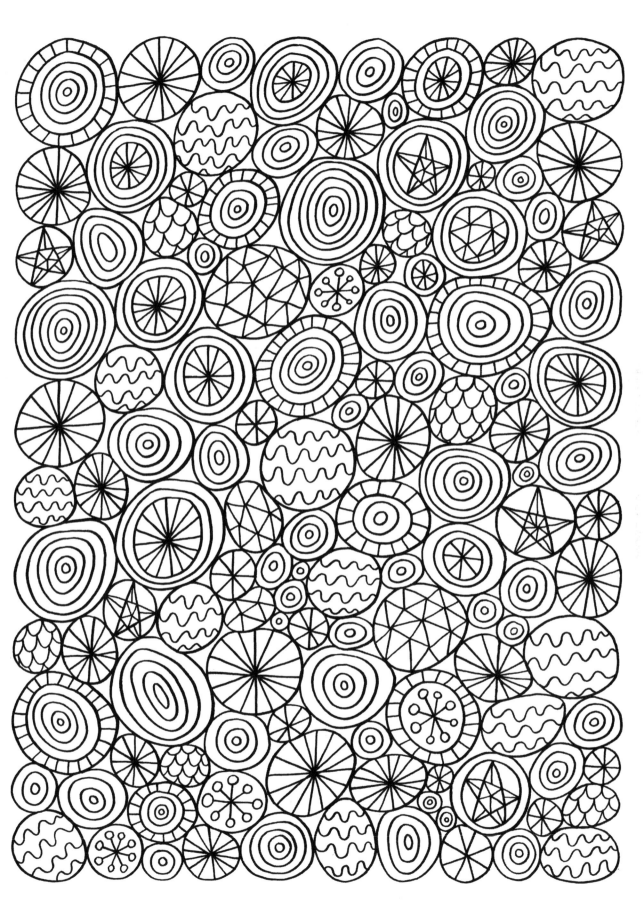

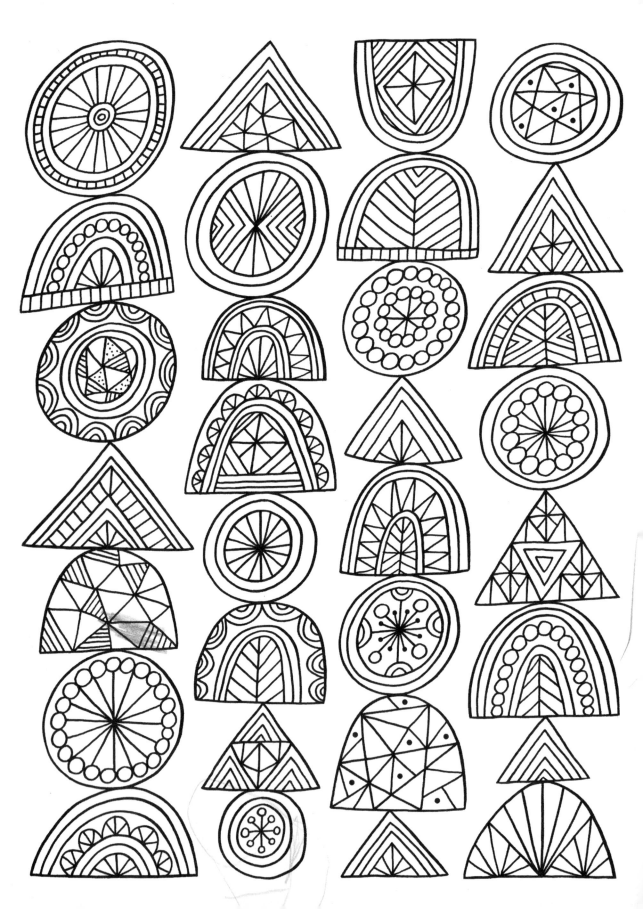

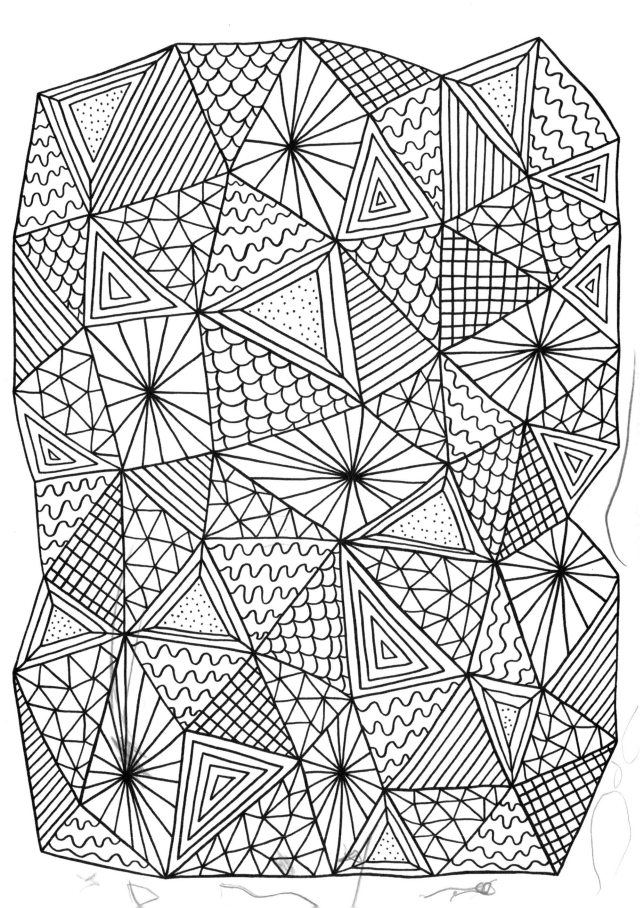

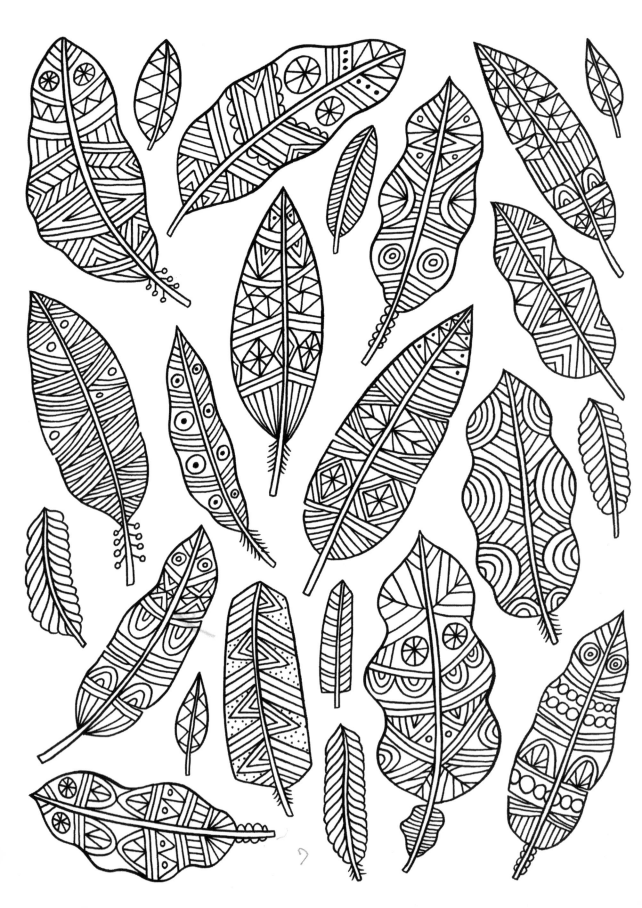

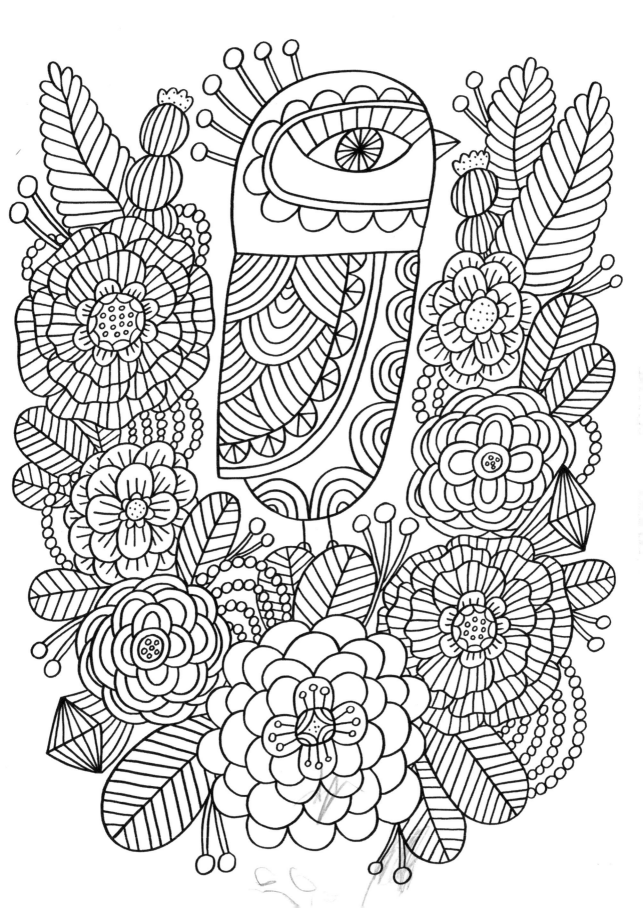

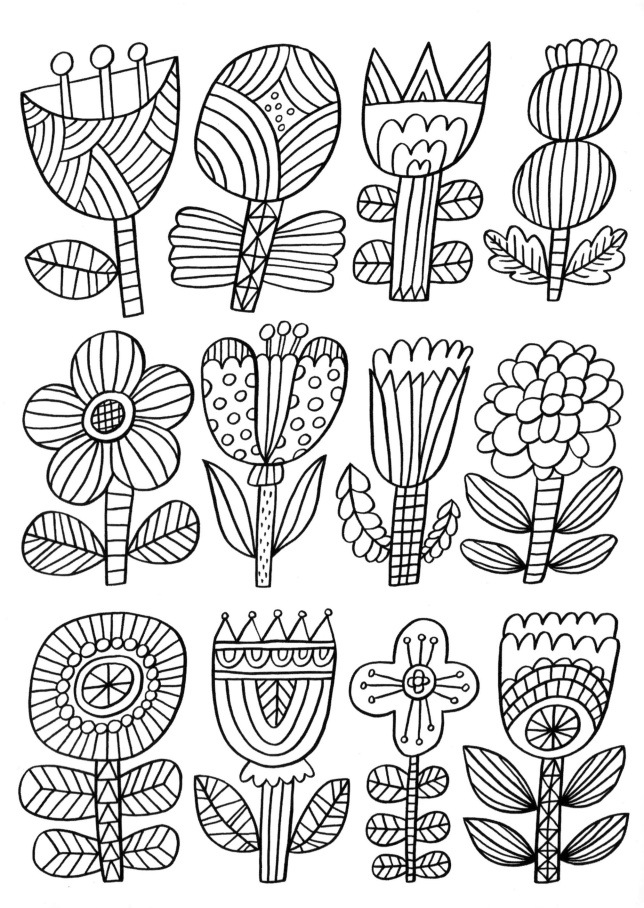

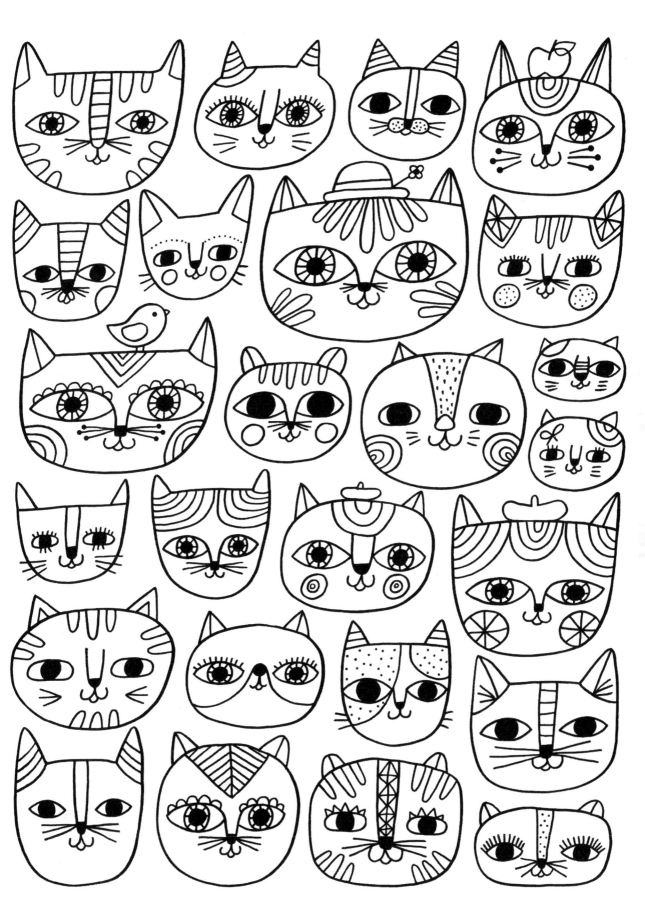

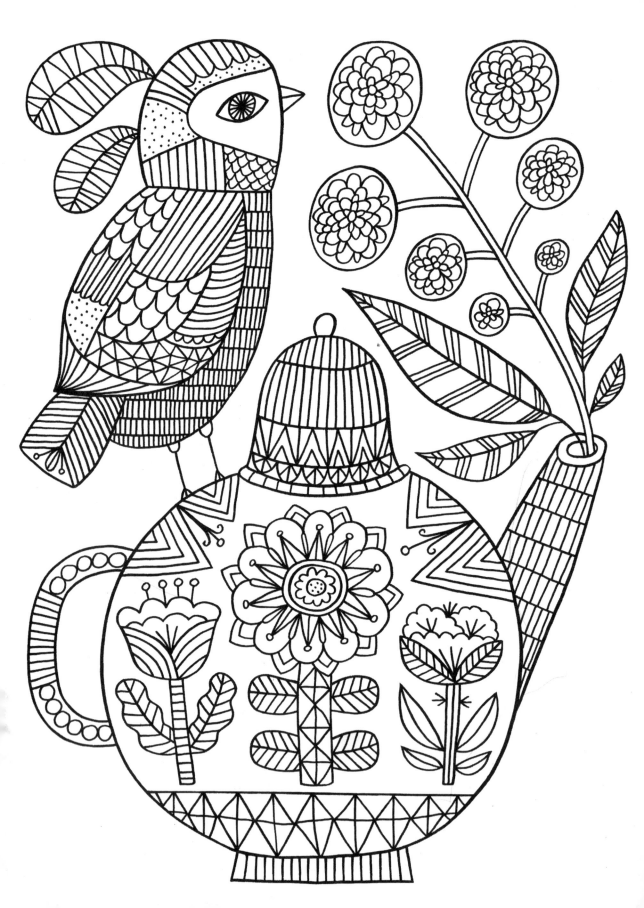

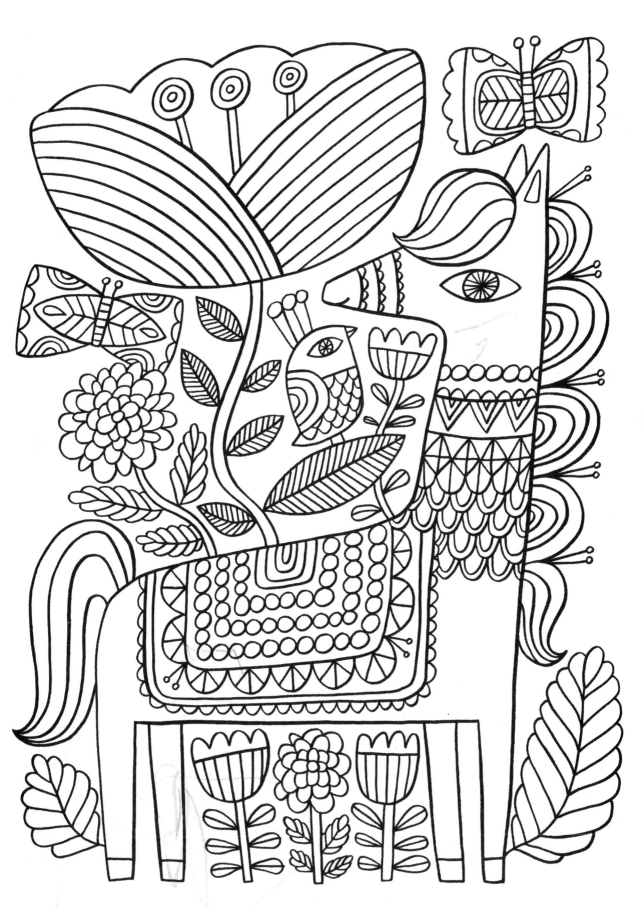

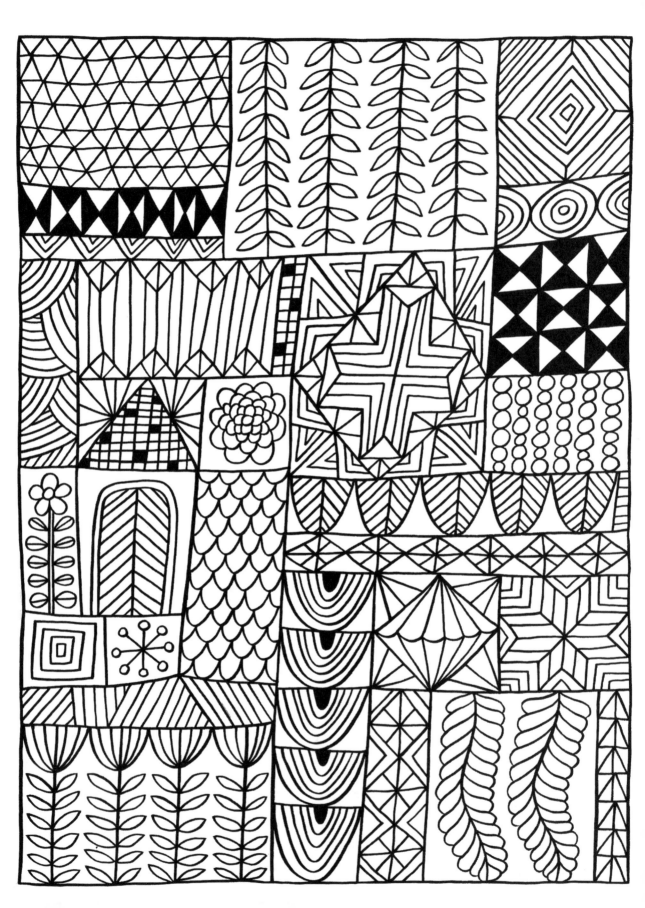

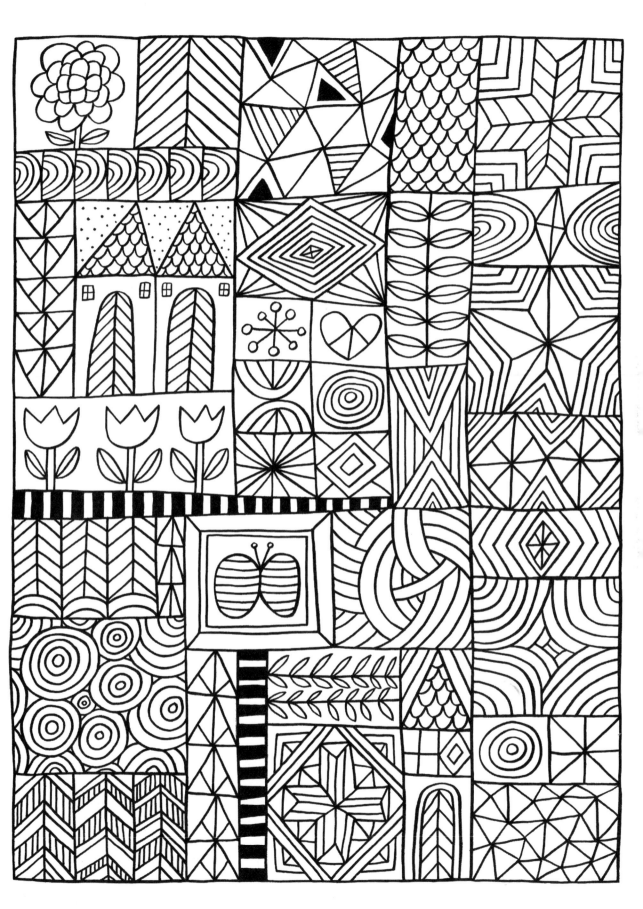

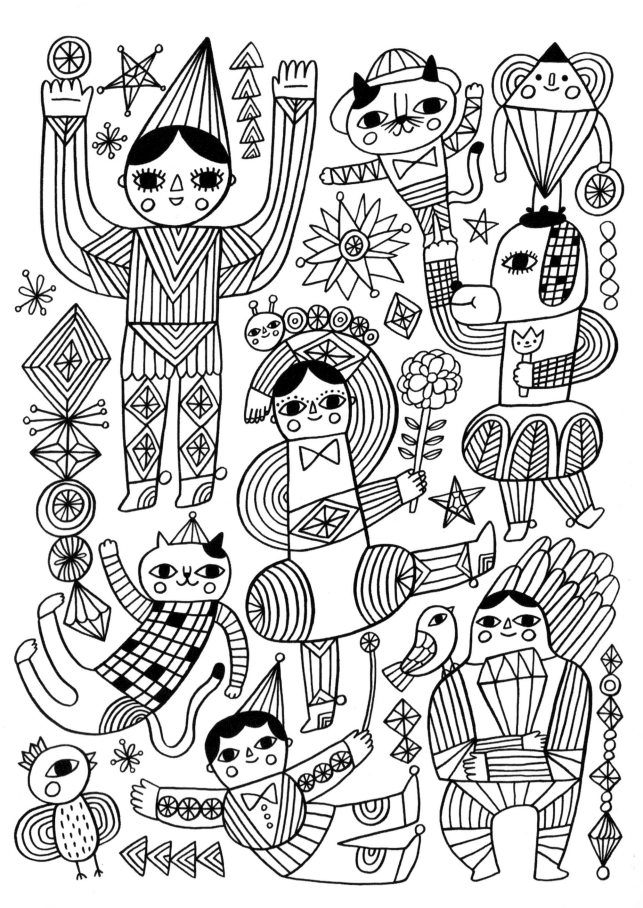

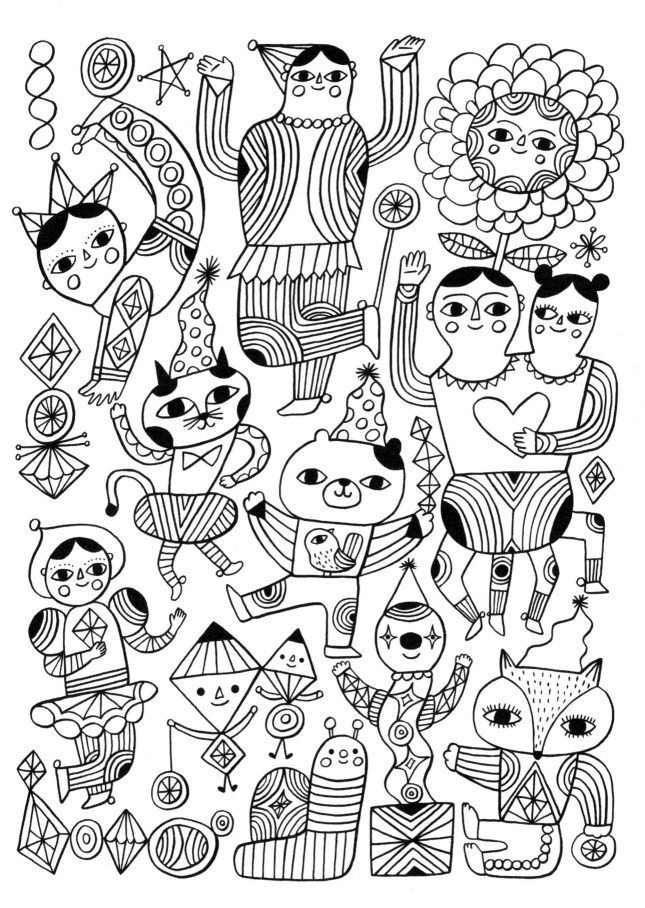

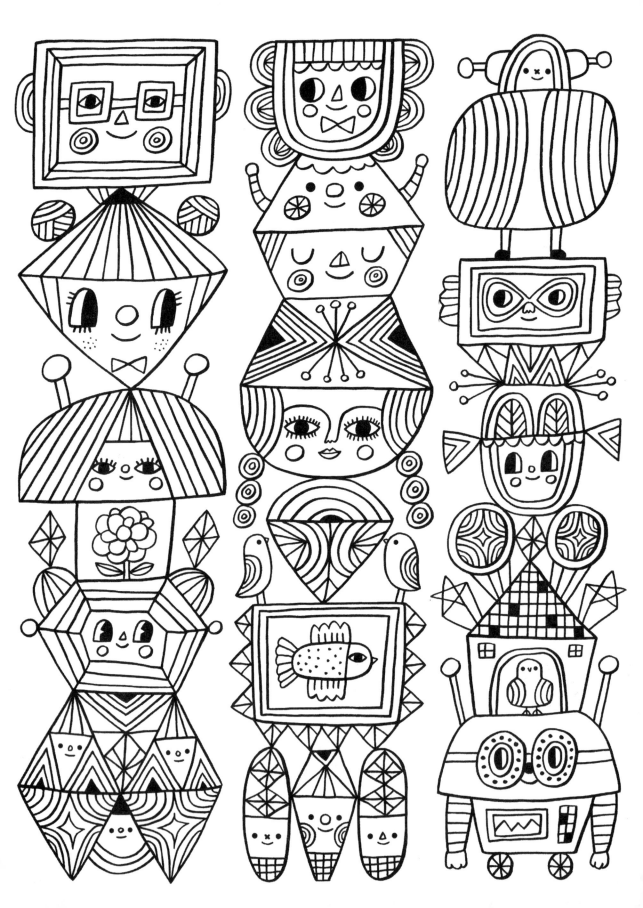

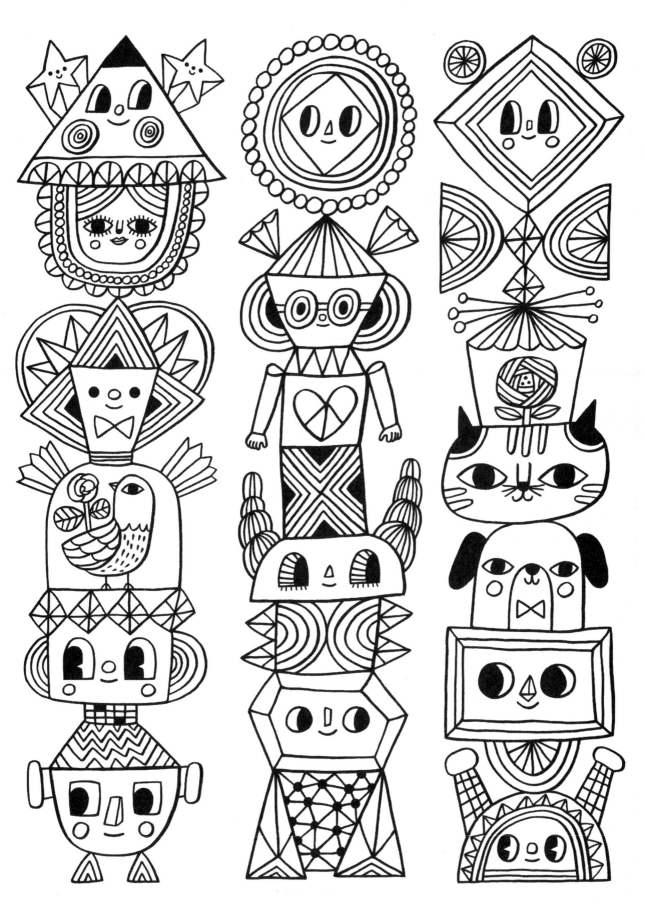

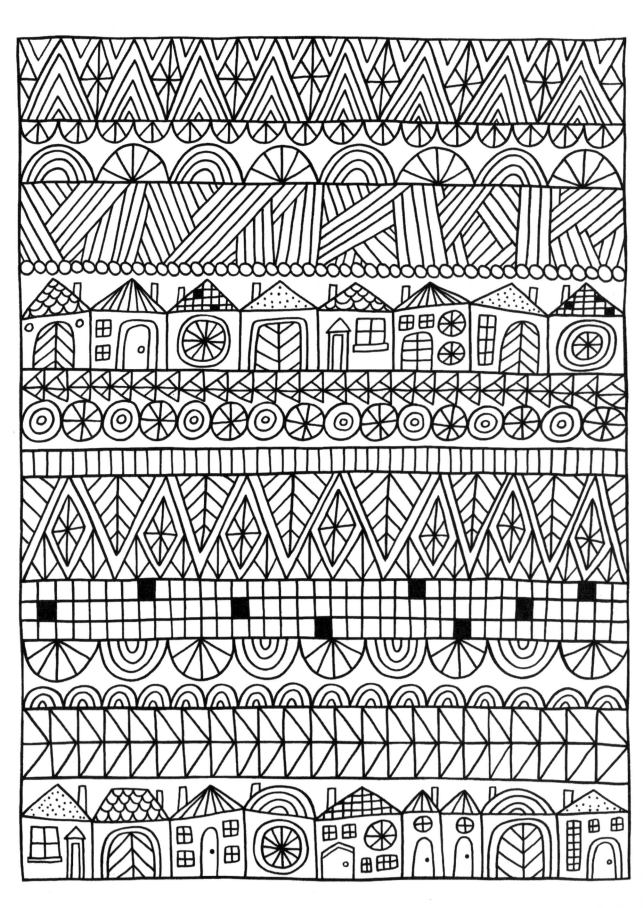

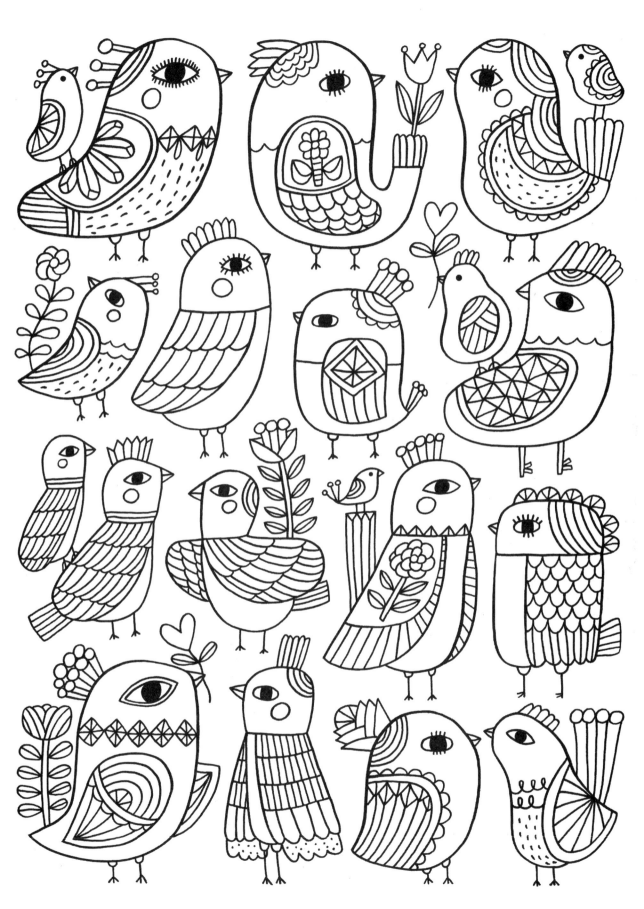

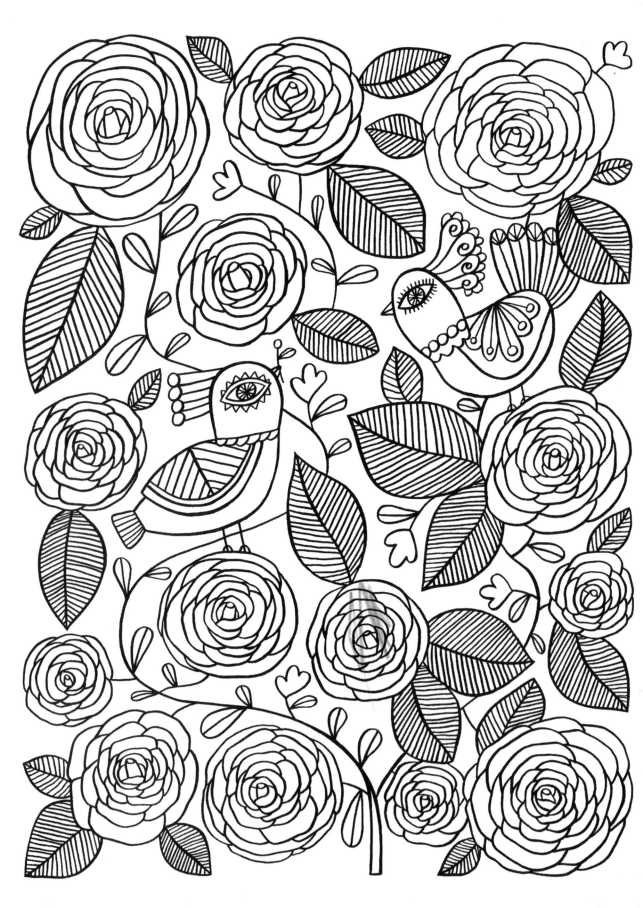

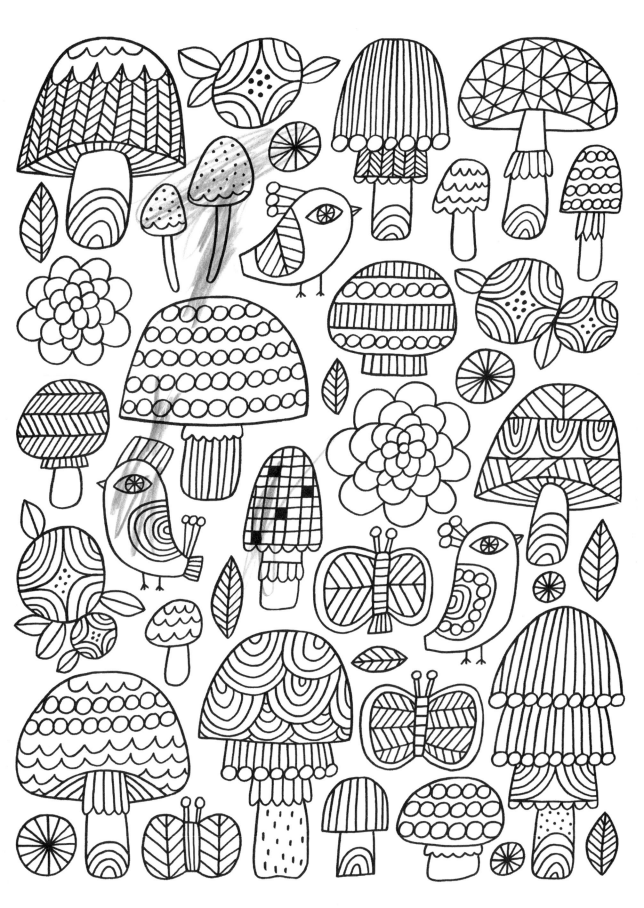

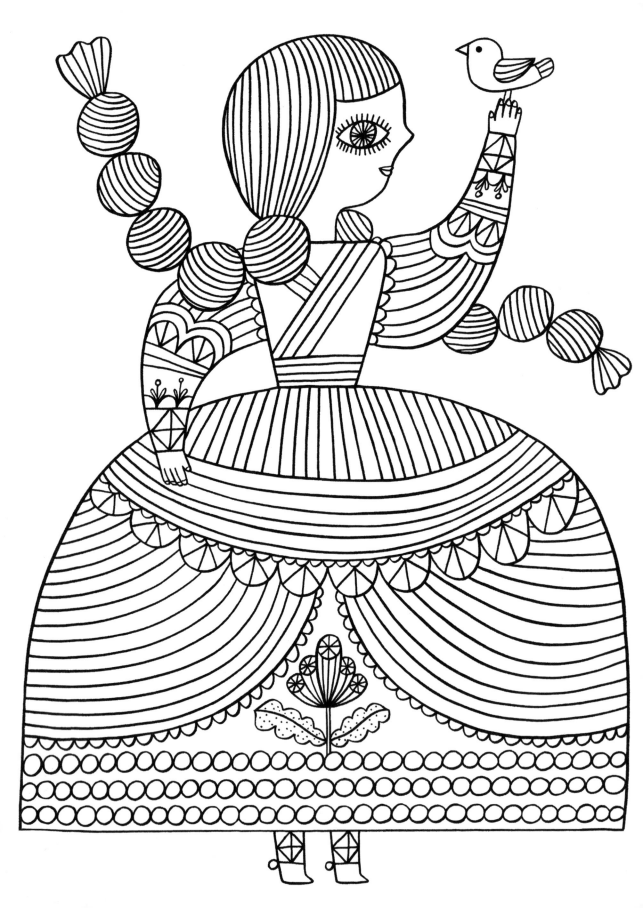

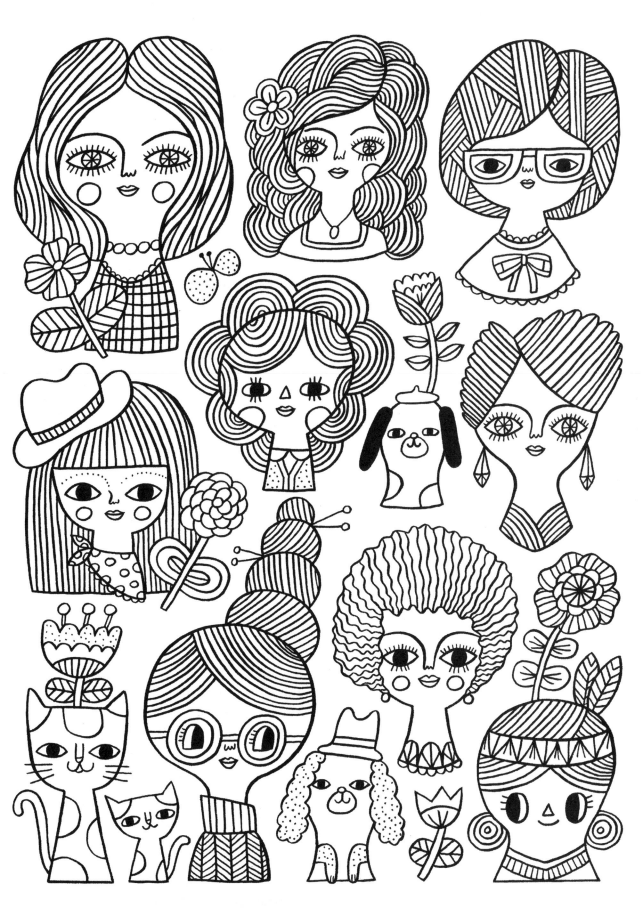

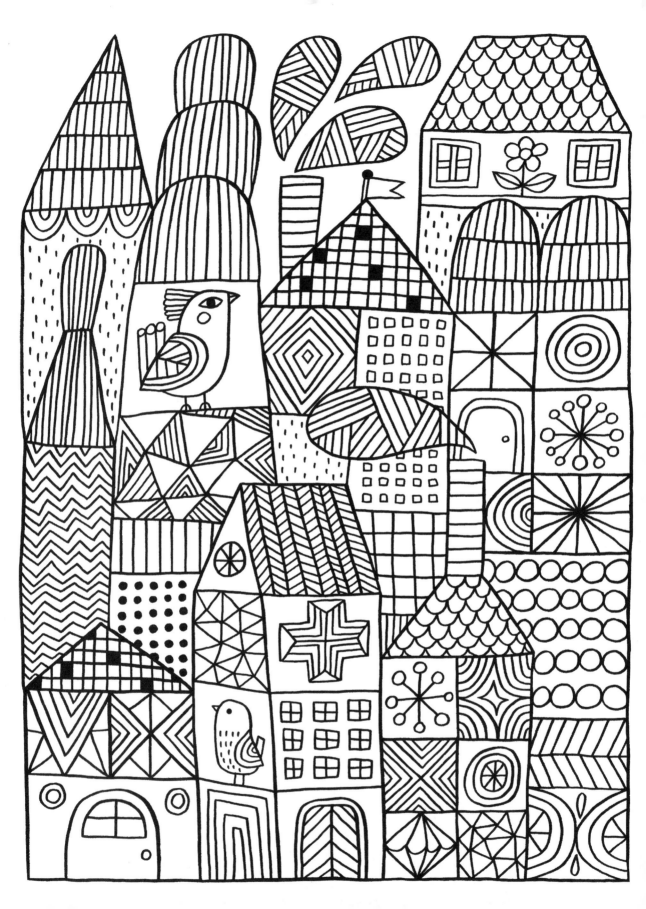

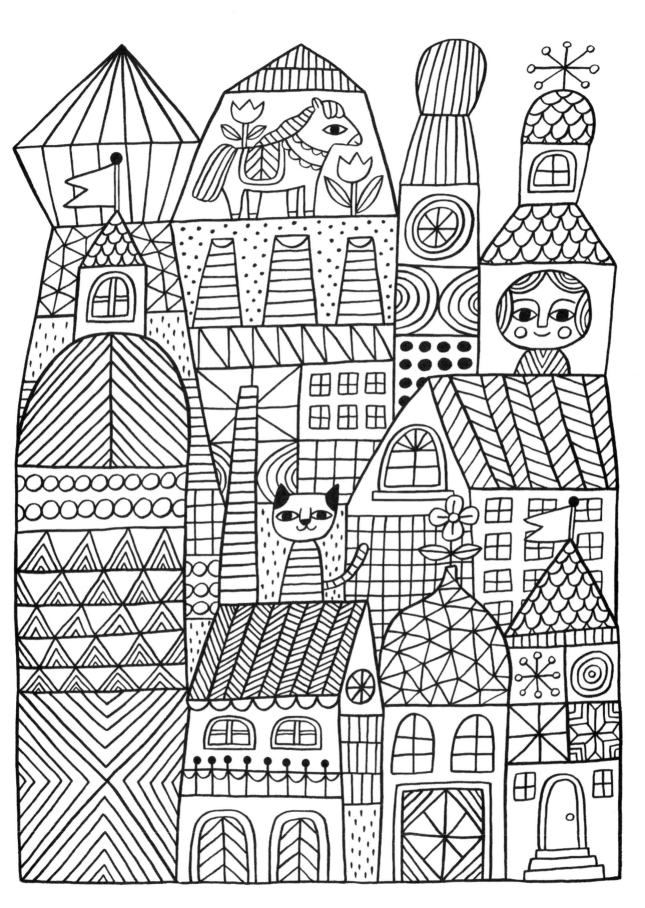

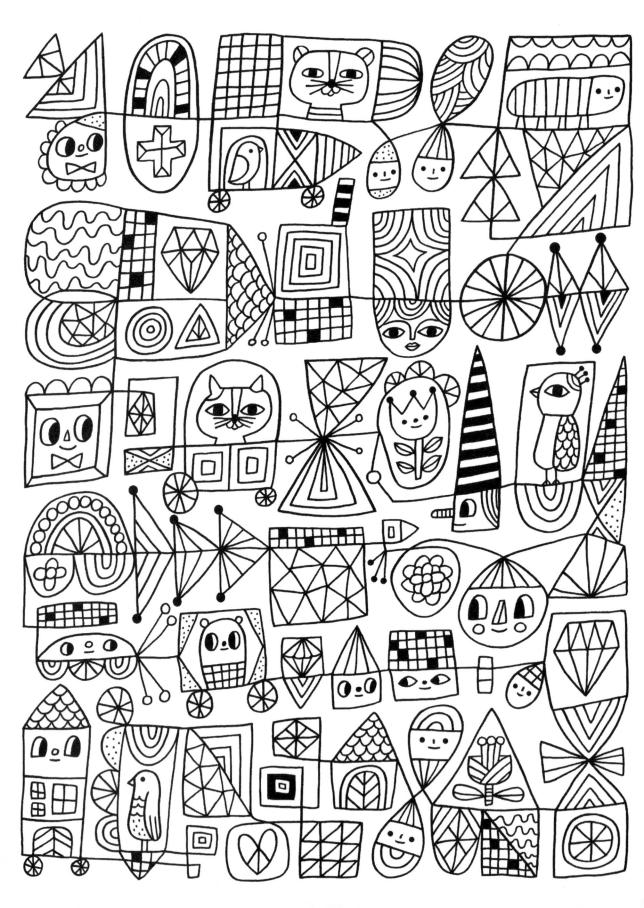

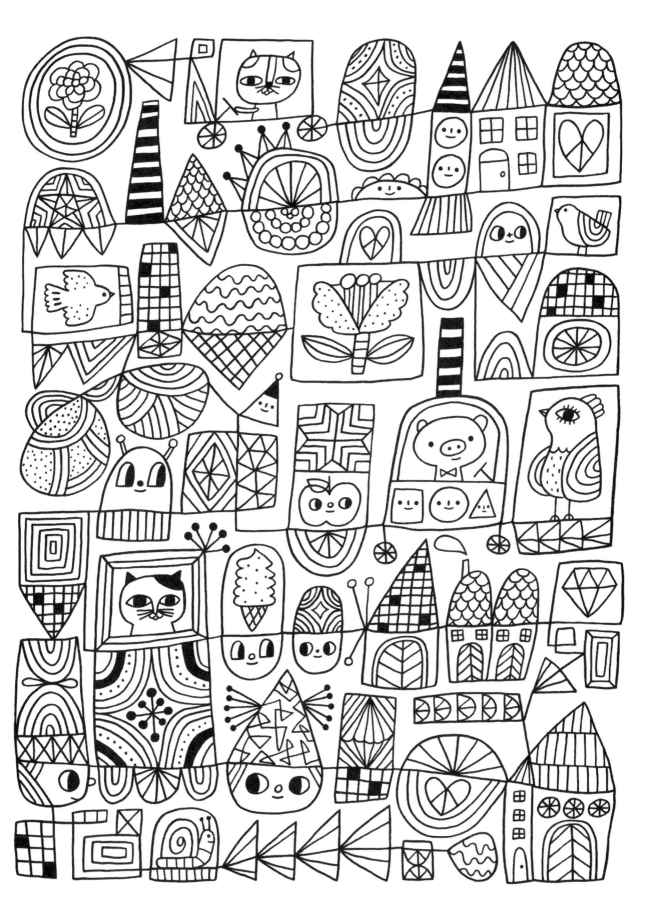

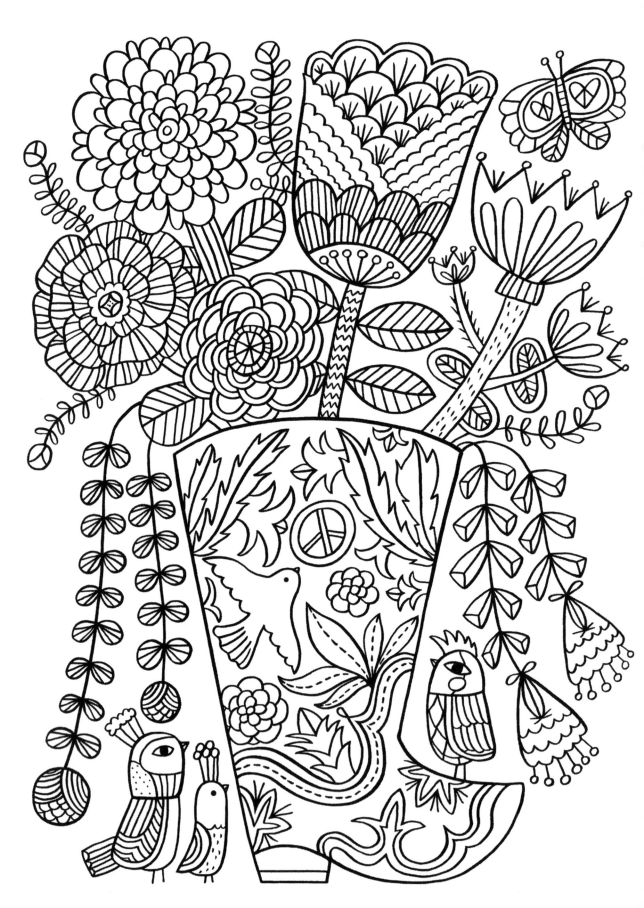

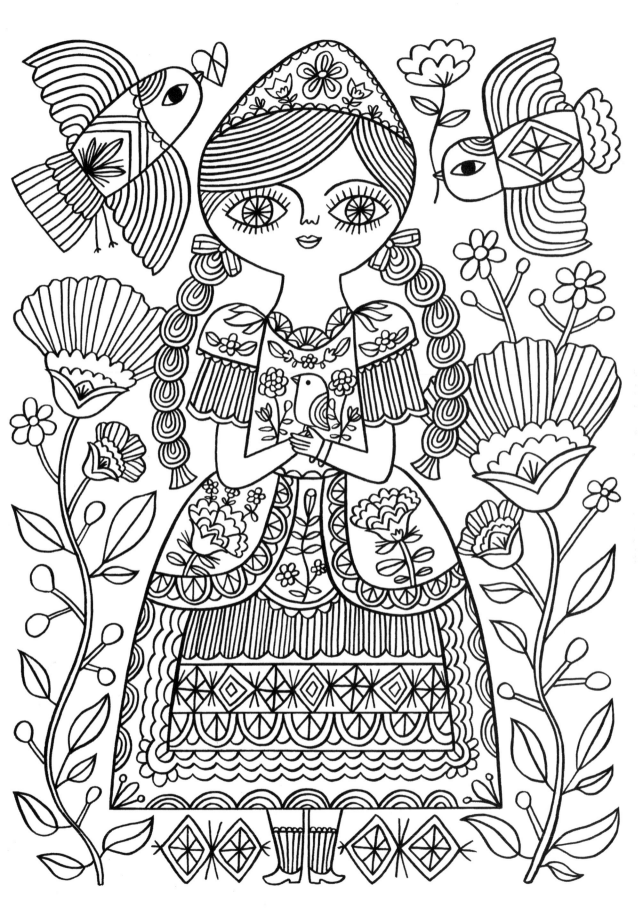

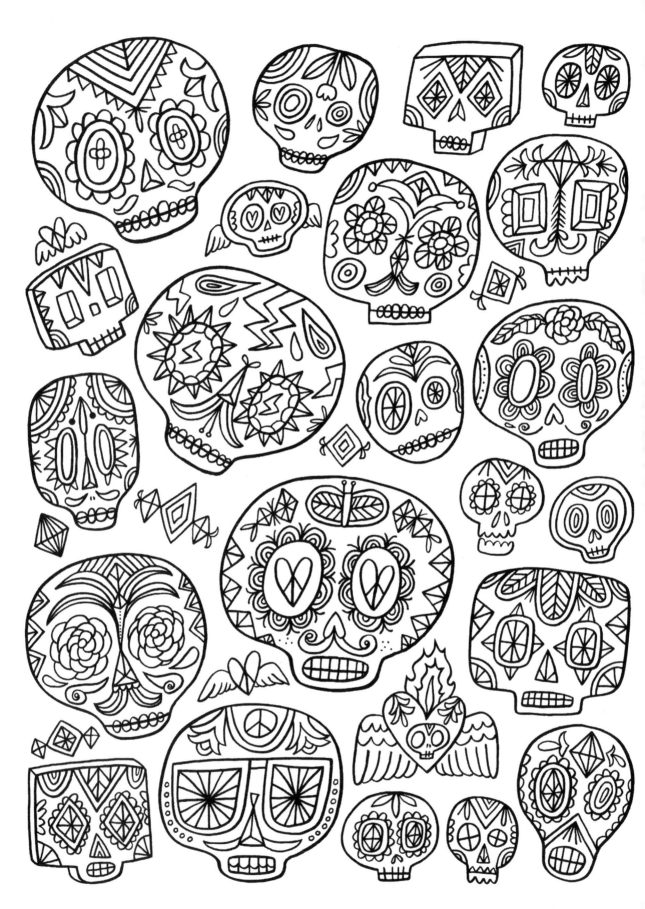

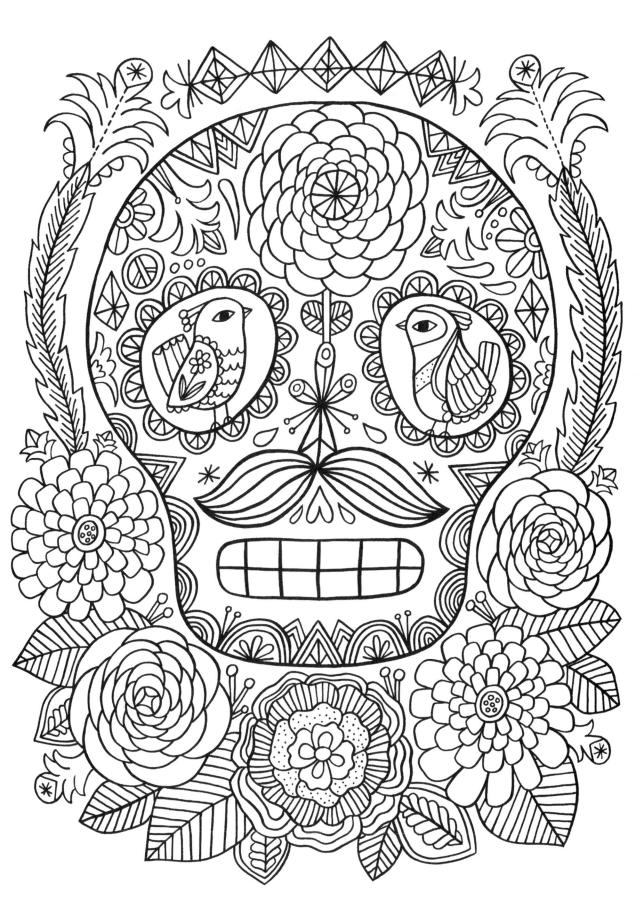

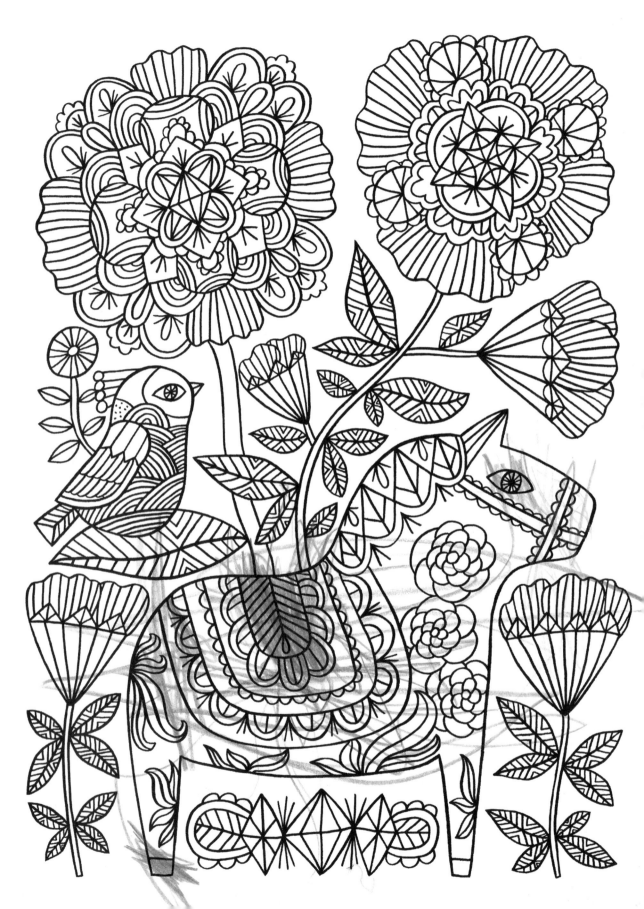

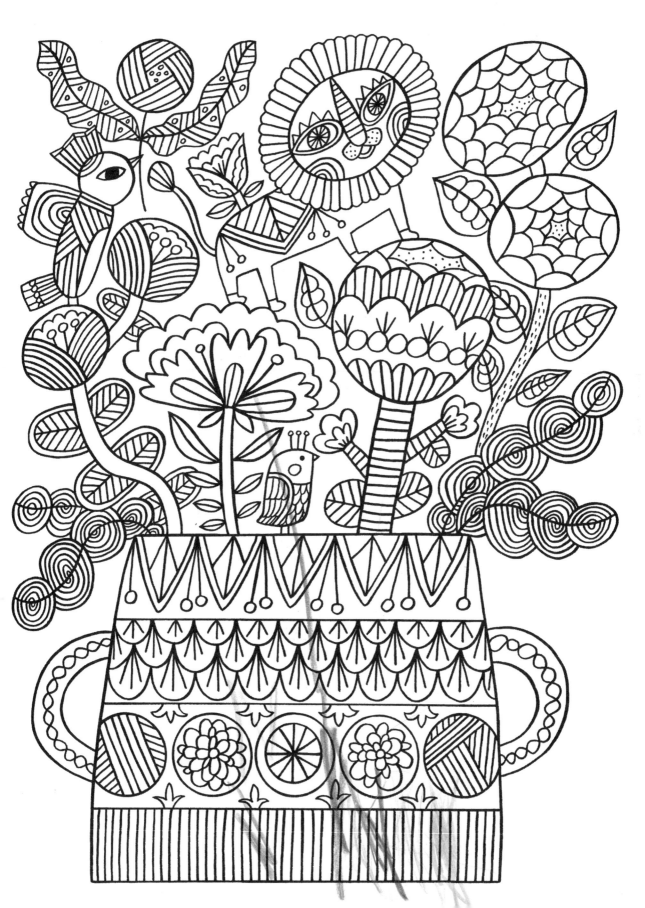

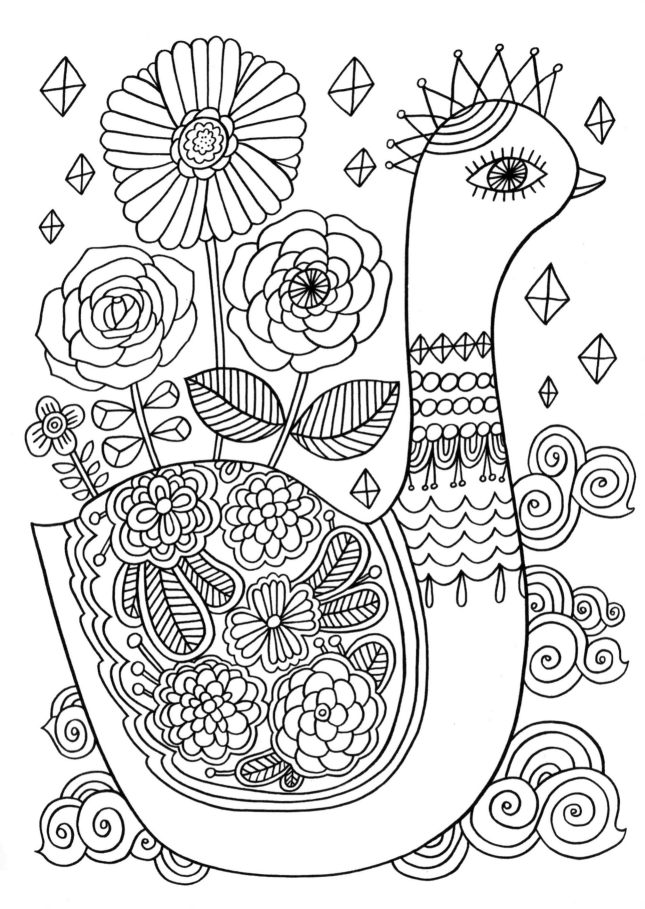

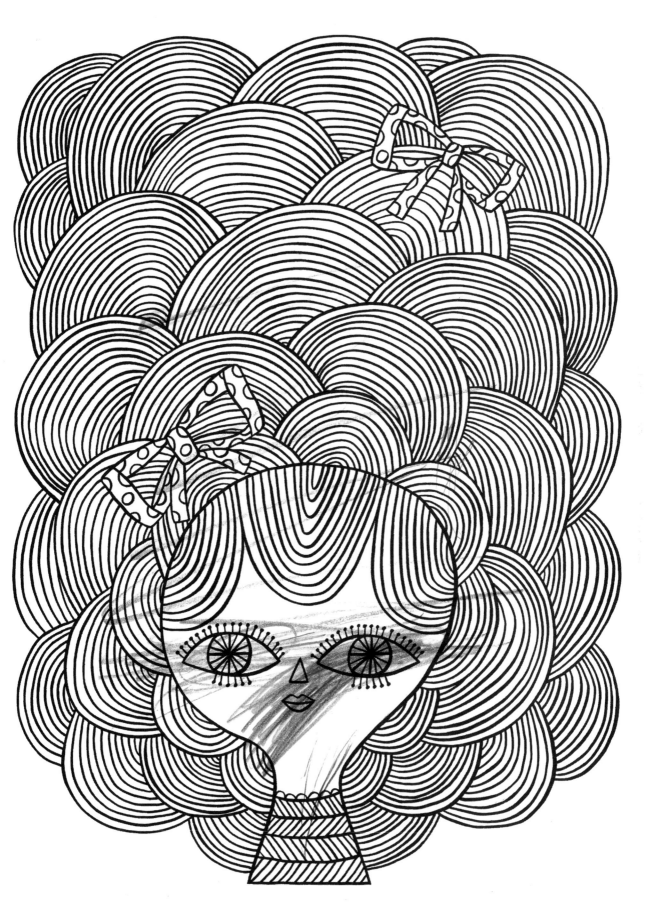

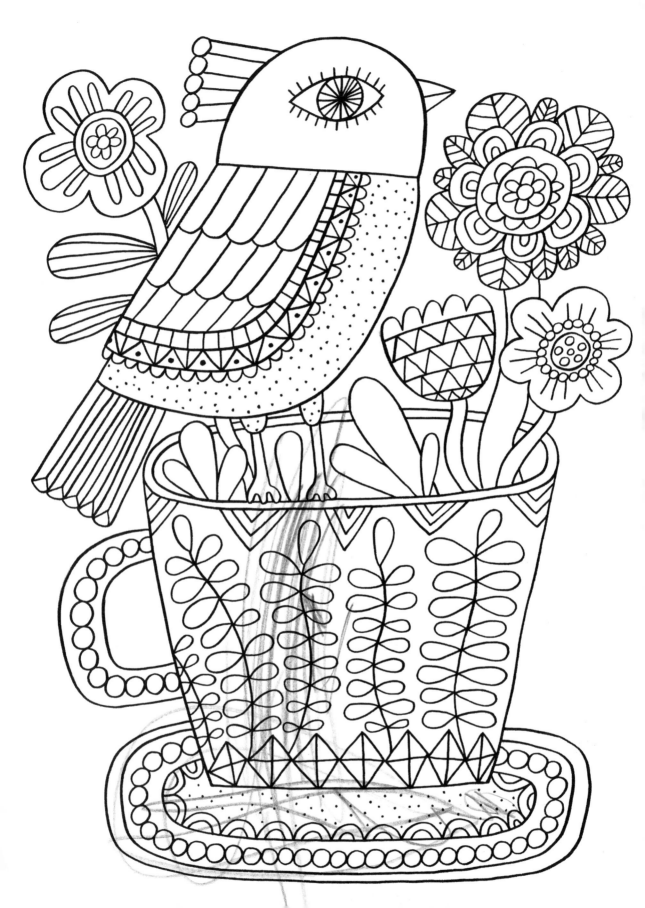

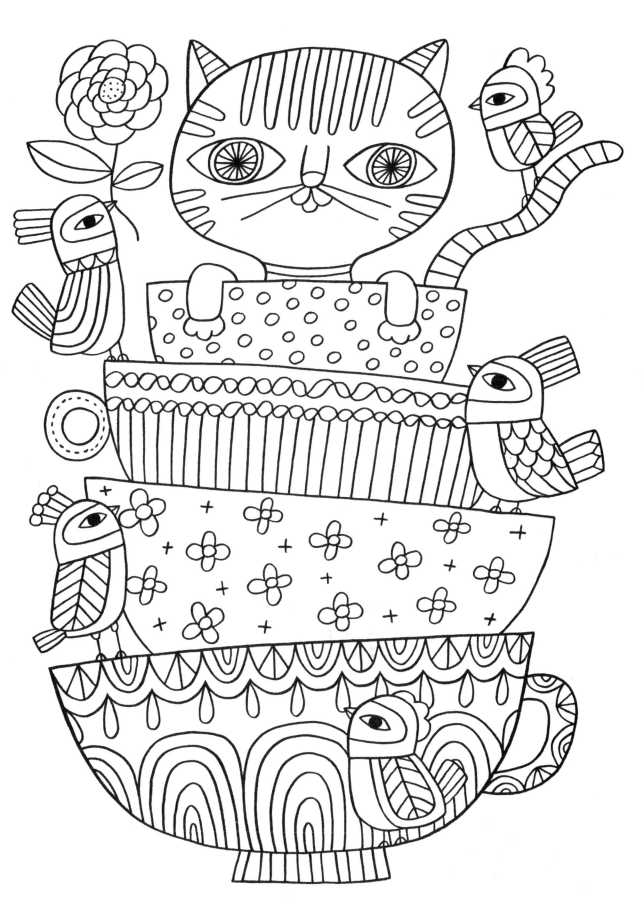

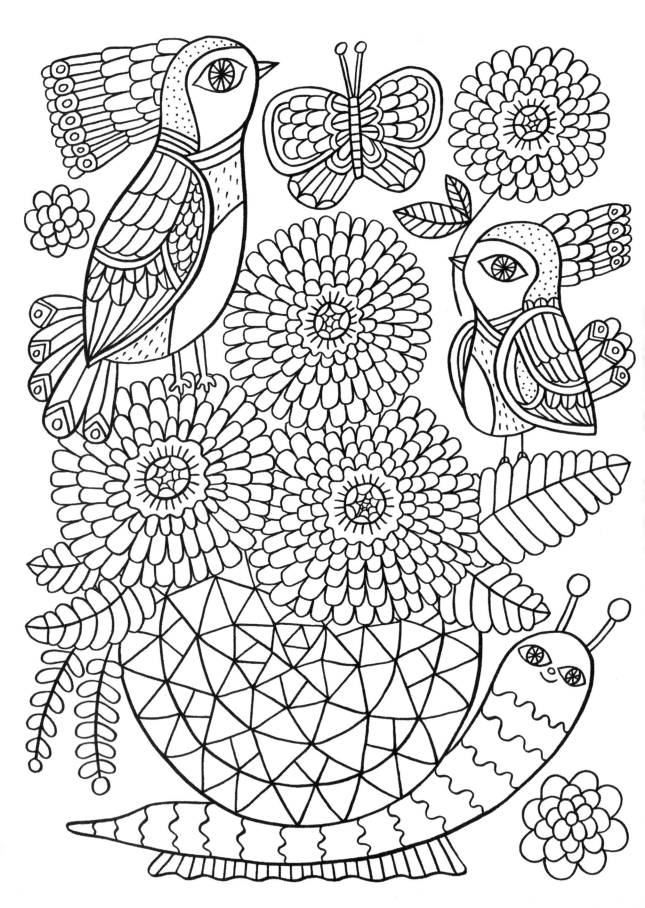

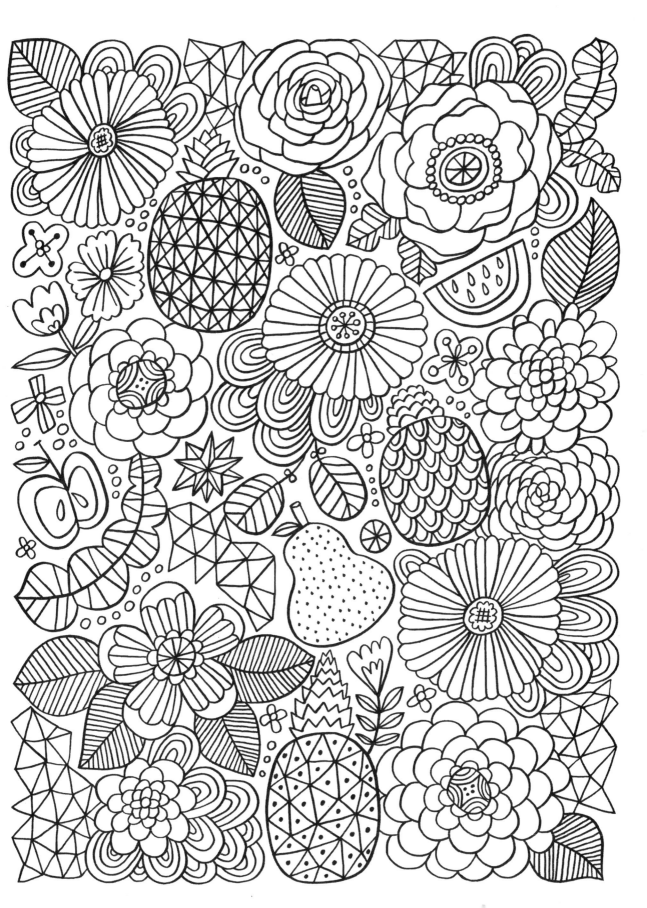

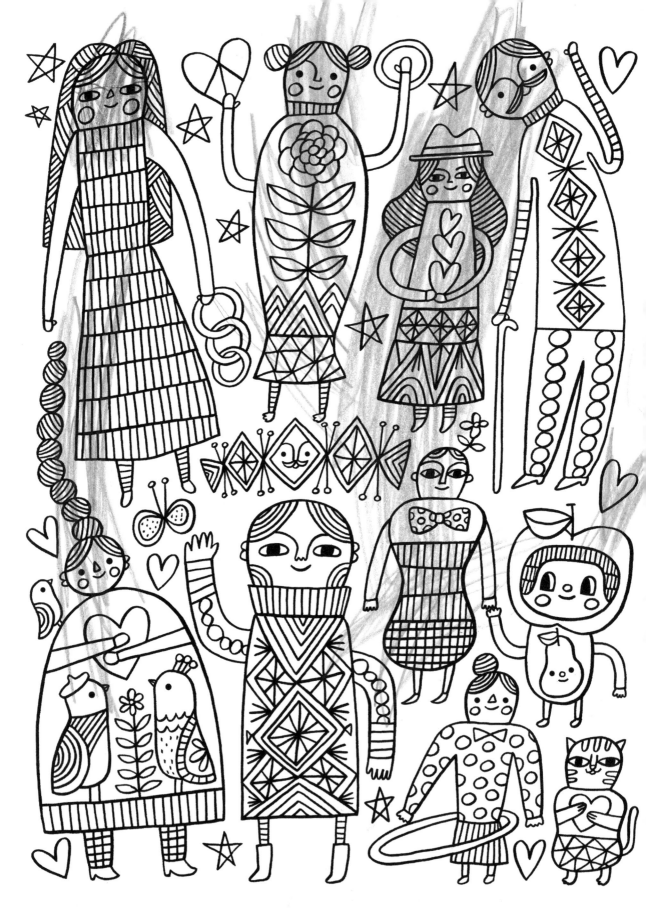

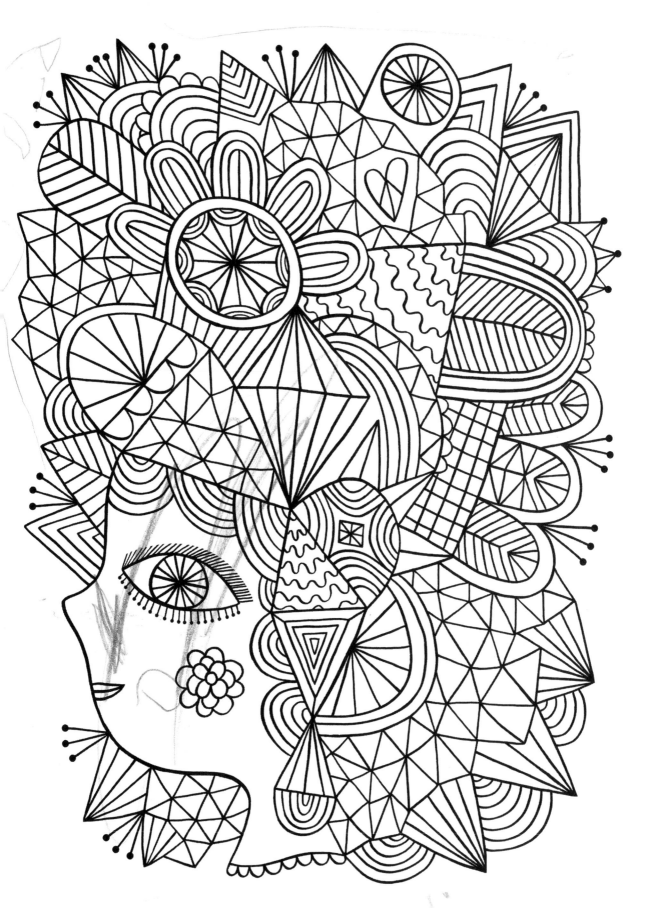

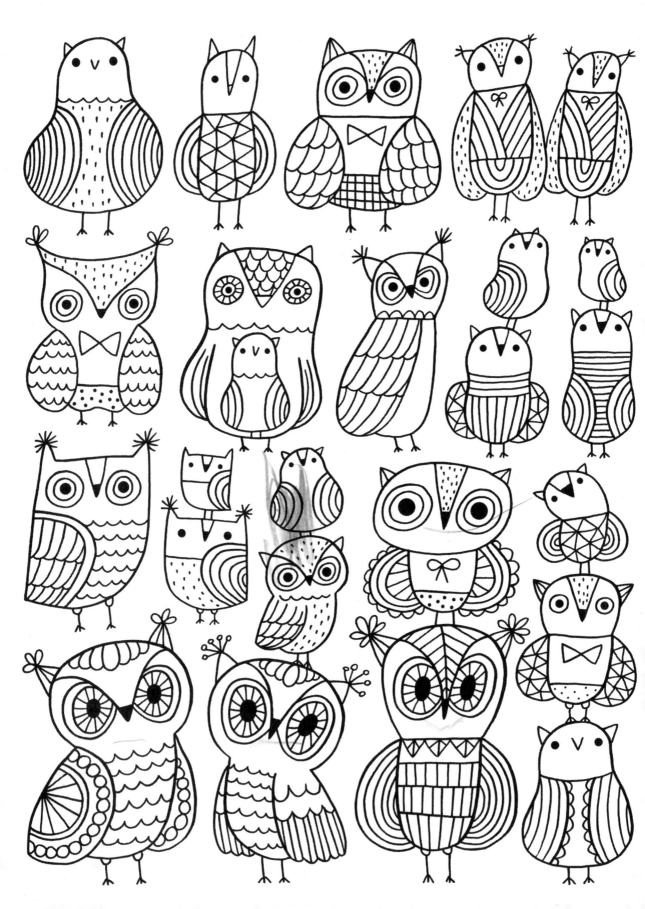